The College History Series

TUFTS UNIVERSITY

D0064102

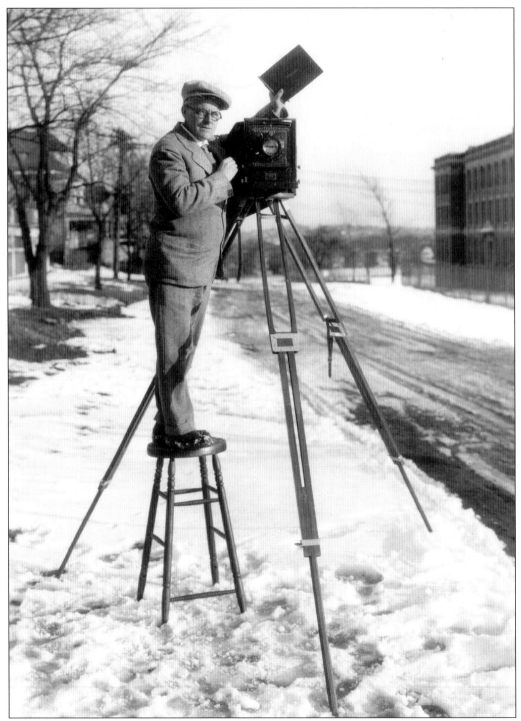

MELVILLE S. MUNRO, *c.* **1935.** Professor of electrical engineering, Munro served Tufts for more than 30 years as an unofficial photographer. His collection of over 30,000 photographs is now a part of the University Archives, documenting campus life in both Boston and Medford from 1910 until 1945.

The College History Series

TUFTS UNIVERSITY

ANNE SAUER

ARCADIA

Copyright © 2001 by Trustees of Tufts College.
ISBN 0-7385-0853-5

Published by Arcadia Publishing,
an imprint of Tempus Publishing, Inc.
2A Cumberland Street
Charleston, SC 29401

Printed in Great Britain.

Library of Congress Catalog Card Number: 2001088375

For all general information contact Arcadia Publishing at:
Telephone 843-853-2070
Fax 843-853-0044
E-Mail sales@arcadiapublishing.com

For customer service and orders:
Toll-Free 1-888-313-2665

Visit us on the internet at http://www.arcadiapublishing.com

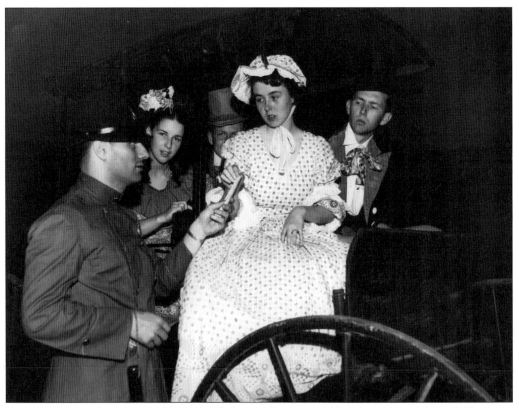

THE CENTENNIAL PAGEANT, 1952. Part of the celebration of Tufts's centennial in 1952 was a costume pageant held in Ellis Oval on the Medford campus. Students dressed in 1850s attire and re-created the events surrounding the founding of the school. Distinguished speakers, a gala ball, and a special degree convocation also marked the important milestone.

CONTENTS

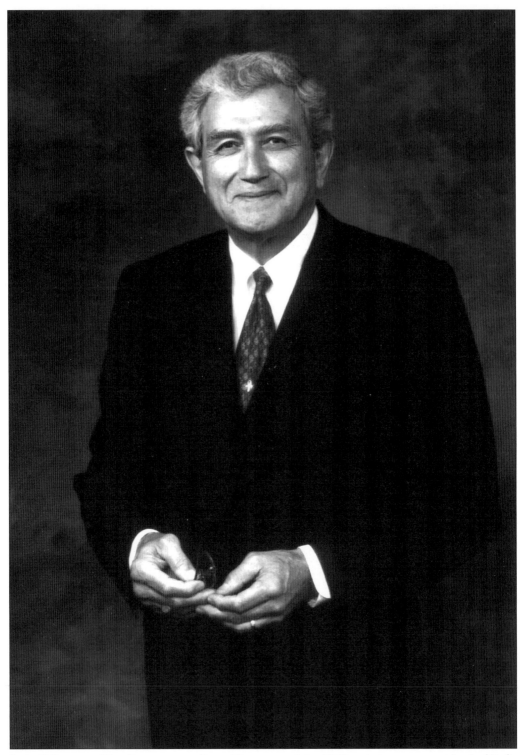

JOHN DiBIAGGIO, 11TH PRESIDENT OF TUFTS UNIVERSITY. John DiBiaggio became president of Tufts University on September 1, 1992.

A Message from the President

In 1852, when Somerville businessman, farmer, and Universalist Charles Tufts was asked what he planned to do with bleak Walnut Hill in Medford, he said that he would put a light on it. In the 150 years that since have passed, the college founded in Tufts's name indeed has been that beacon. From its humble beginning with one building, four faculty members, and seven students, Tufts has grown to include four campuses, seven schools, and more than 8,000 students in an unprecedented variety of liberal arts and professional programs.

This commemorative book offers a glimpse of Tufts through the first 150 years of its history. Photographs of students, faculty, administrators, staff, alumni, and alumnae capture Tufts's history and reflect both continuity and change at the institution. The historical photographs selected for this volume highlight themes that have been central to Tufts's mission since its founding: teaching, leadership, culture, and citizenship.

Teaching of the highest quality always has been at the core of Tufts's mission. A student-centered university, Tufts today concentrates on providing excellent learning opportunities for students both in the classroom and beyond.

Tufts has enjoyed superb leaders among its faculty, students, and administrators and their contributions have helped to make this institution the outstanding university that it is today. Members of the Tufts community have distinguished themselves off the hill as well, as natural and social scientists, educators, engineers, artists, diplomats, health and nutrition professionals, and leaders in other fields.

Tufts has a wonderfully unique culture that ranges from scholarly and serious to playful and outright fun. We delight in the pomp of matriculation and commencement, and in the ensuing years grow fiercely loyal to our beloved mascot, Jumbo.

Tufts always has been part of a larger community. Throughout its history, the institution has encouraged public service, be it local, regional, or global. In times of war and peace, Tufts's people have been active participants in the world around them.

Tufts University today is a complex, dynamic center of learning that is global in its reach. Each college and center focuses on a particular area of expertise, yet Tufts succeeds in fostering the cross-disciplinary cooperation that makes this university a truly special place. As Tufts looks ahead with great confidence to its next 150 years, I invite you now to share in moments from its remarkable history.

—John DiBiaggio
President

Acknowledgments

This project could not have been accomplished without a great deal of support. I would like to take this opportunity to thank those who participated in this publication as it progressed from conception to completion.

First, thanks to President John DiBiaggio for his support and for generously agreeing to write the introduction for this book. Provost Sol Gittleman and Vice President Steve Manos championed the project from its earliest inception, providing the resources to make it possible. Both of them reviewed the final draft of the book and their thoughtful comments were very much appreciated.

Greg Colati, director, Digital Collections and Archives, was the driving force behind this book, ensuring that the staff and resources necessary to make it a success were in place. His collaboration and invaluable advice on image selection and captions were an essential part of making this book what it is.

Special thanks go to Carrie Allen, G2002, for her tireless work in scanning and preparing images for the book, as well as assisting with preparation of the text. Also, thanks go to John Bennett, A2001, and Jessica Branco, J2000, research interns for the *Concise Encyclopedia of Tufts History,* whose research assistance was the foundation of the historical information contained in the captions. Leah Nelson, intern in the Simmons College Graduate School of Library and Information Science archives management program, processed the Melville S. Munro collection, helping to make his many outstanding photographs of Tufts history available for use here.

Sheri Kelley, assistant archivist for Records Management, provided support and advice throughout the project. Rocky Carzo, athletic director emeritus, gave valuable advice on athletics at Tufts. Dr. Henry Banks of the medical school and Elizabeth Richardson of the health sciences library were very helpful in assisting with pictures of the medical school.

A Note on Graduation Dates

Throughout the book, graduates are identified both by school affiliation and year of graduation. The following school abbreviations are used in this book:

A	Liberal Arts	J	Jackson College
E	Engineering	M	School of Medicine
G	Graduate School of Arts and Sciences	R	School of Religion
H	Honorary	W	Woman of Arts

One
TEACHING, LEARNING, AND RESEARCH

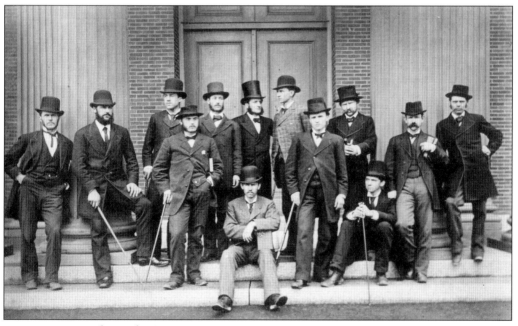

THE CLASS OF 1876, 1876. The graduating class poses for its portrait on the steps of Ballou Hall. The curriculum at the time was a fixed course of study, including Latin, Greek, rhetoric, mathematics, moral philosophy, and the sciences. There were 11 faculty and 69 students enrolled in the college.

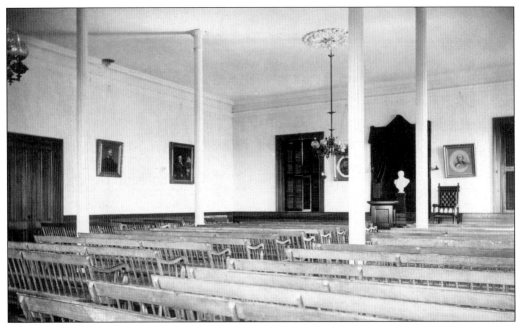

BALLOU CHAPEL, C. 1880. This room on the second floor of Ballou Hall was the main chapel for the college until replaced by Goddard Chapel. This chapel was large enough to accommodate most student and faculty gatherings and was the site of the college's second commencement. Daily chapel services were once required of all students.

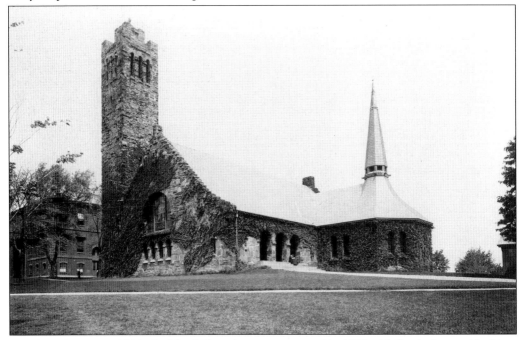

GODDARD CHAPEL, C. 1900. Goddard Chapel was constructed in 1882 with funds donated by Mary T. Goddard in her husband's honor. It replaced the "Large Chapel" located on the second floor of Ballou. The blue-gray slate of its construction was quarried in Somerville. The chapel, of a modified Romanesque style, was for a time known as the most photographed chapel in America.

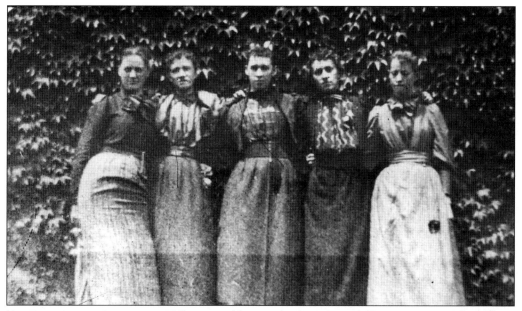

THE FIRST WOMEN STUDENTS, 1896. Pictured here is the first class of women students to complete the full course of studies and graduate from Tufts. Shown, from left to right, are Angie B. Markeley, Gertrude Drowns, Ethel M. Hayes, Blanch H. Roy, and Laurie Frazeur, all of the Class of 1896. Henrietta Noble Brown, W1893, the first woman to graduate, transferred to Tufts with only one year of studies to complete.

CANDIDATES FOR WINTER QUEEN, 1966. A winter carnival held in January or February featured a ball at which a winter queen was chosen. These candidates pose on the roof of newly constructed Wessell Library.

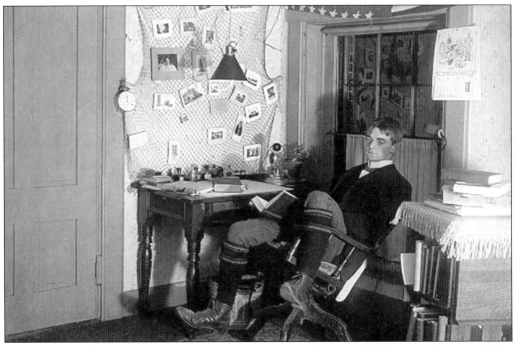

A Student Room in Packard Hall, c. 1900. In the early years of dormitory living at Tufts, students had to pay for their own heat in the form of coal for stoves placed in each room and oil for lamps to read by. This room shows an early electrical fixture for light over the desk.

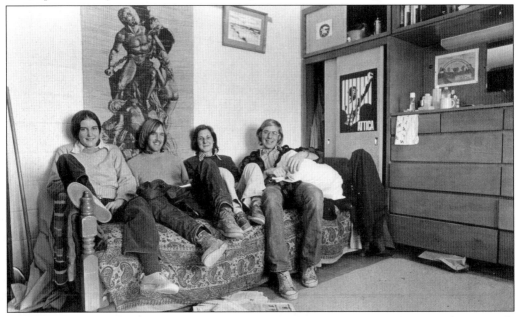

Dorm Scene, 1974. This typical dorm room, probably in Houston Hall, shows how greatly times had changed since the 1890s. One of the most notable differences is the advent of coed dormitories, instituted in 1972. Modern advances in digital communications have also been incorporated into dorm life, as high-speed web access and cable have been installed in every room.

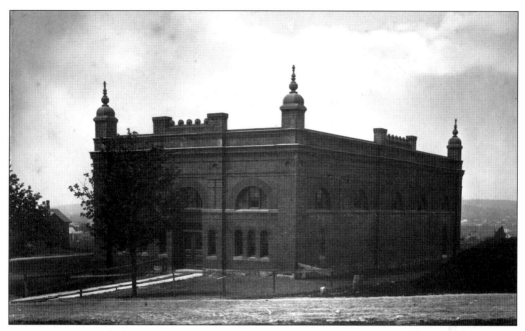

GODDARD GYMNASIUM, 1887. Shown here, only a few years after its construction in 1883, Goddard Gymnasium was the first athletic facility constructed at Tufts. Prior to its completion, students exercised on equipment situated behind West Hall or by running around the Reservoir. Two hours of gymnasium work per week were required of all students.

THE FLETCHER SCHOOL OF LAW AND DIPLOMACY, c. 1950. The Fletcher School was established in 1933 as the first graduate school of international affairs in the United States. From the beginning, Fletcher has provided advanced training for those planning careers in the foreign service, international business, or international organizations. The Fletcher School took over the old Goddard Gymnasium after extensive renovations were made.

13

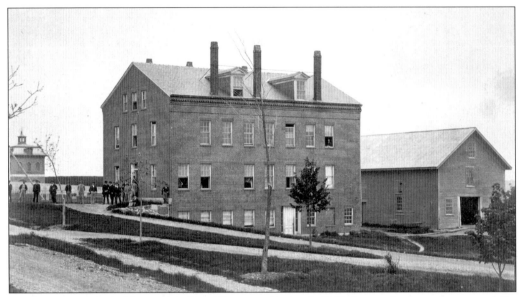

MIDDLE HALL, 1875. This view of Middle, now Packard, Hall shows the large barn used for livestock and storage of farming tools. At the time, crops and livestock were raised on campus for the boardinghouse table. The barn also contained latrines for residents. It was torn down in 1876.

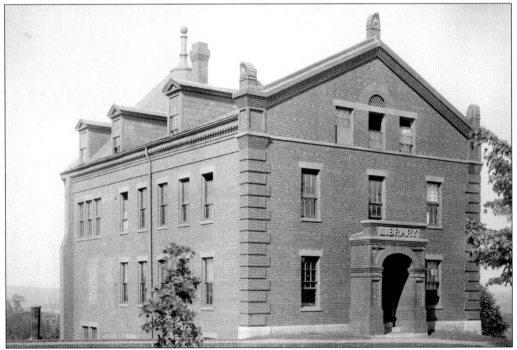

THE LIBRARY, C. 1890. When the library outgrew its cramped quarters in Ballou Hall, it was moved to Packard Hall. The stacks were housed in a curved addition to the back of the building. Students continued to live in the building until 1901. With the completion of Eaton Library in 1908, Packard Hall was used for administrative purposes. The College Pump is visible to the left of the building.

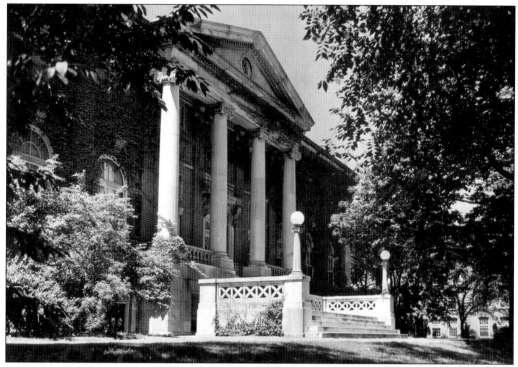

EATON LIBRARY, c. 1950. Tufts's new library, built in 1908, was one of the first college libraries built with Carnegie Foundation funds. It was named at Carnegie's wife's request for Charles Henry Eaton, A1874, R1877, who officiated at the Carnegies' wedding. The War Memorial Wing was added in 1950, nearly doubling the size of the library. With the completion of Wessell Library in 1965, Eaton was converted to classroom and office space.

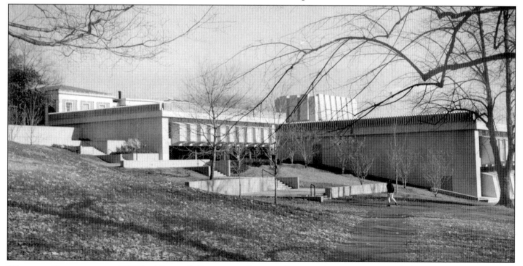

WESSELL LIBRARY, c. 1970. Named for president Nils Y. Wessell, the new library for Arts and Sciences was completed in 1965. The design, recessed into the hillside, was chosen in a competition among four architectural firms for its integration into the existing topography of the campus. Wessell Library served Arts and Sciences for more than 30 years before being dramatically expanded in 1997 and renamed Tisch Library.

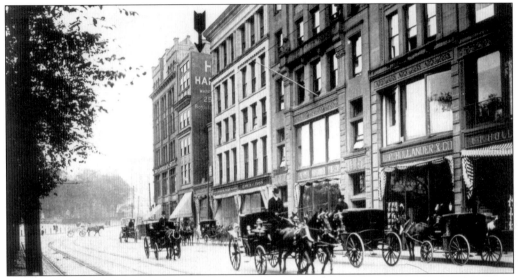

THE MEDICAL SCHOOL, 1893. When the medical school opened in 1893, it was located at 188 Boylston Street in Boston, across from the Public Garden. After only three years at this location, the school's growth required that it relocate to larger facilities elsewhere.

THE MEDICAL SCHOOL, c. 1910. In 1897, the School of Medicine moved to this former Baptist church on Shawmut Avenue in Boston, from its former location at 188 Boylston Street. With the establishment of the dental school in 1899 and a period of steady growth that made the medical school the largest in New England by 1905, a new facility was needed.

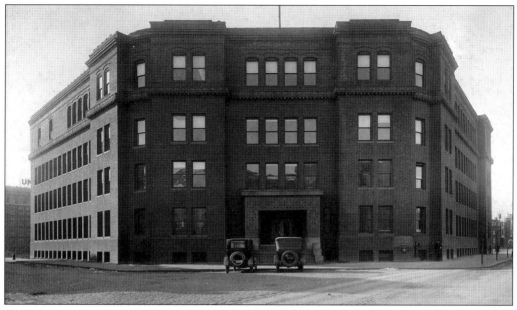

THE MEDICAL AND DENTAL SCHOOLS, C. 1910. This building at 416 Huntington Avenue was the fourth home of the School of Medicine and the first of the School of Dental Medicine. Constructed in 1900, the medical school occupied the right side while the dental school was located on the left. The rapid growth of both schools, combined with the desirability of being closer to teaching hospitals, prompted relocation to the current downtown campus.

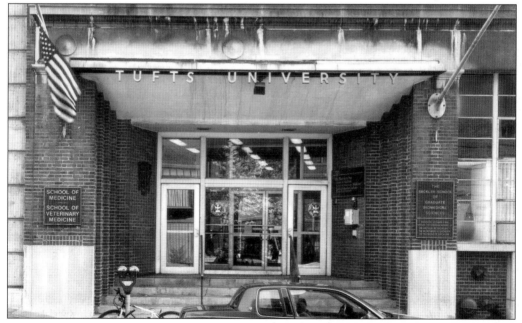

THE SCHOOL OF MEDICINE, C. 1980. The current home of the School of Medicine at 136 Harrison Avenue in Boston was shared with the School of Veterinary Medicine until 2000. Since 1949, the Boston Campus has expanded dramatically, with facilities for the School of Medicine, the School of Dental Medicine, the Human Nutrition Research Center, the Sackler School of Biomedical Sciences, and the New England Medical Center, Tufts's main teaching hospital.

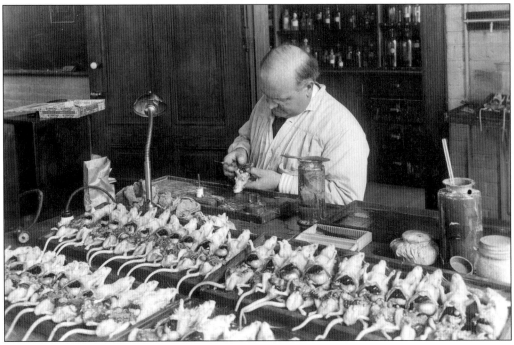

DISSECTION PREPARATION, C. 1930. Professor Lambert of the biology department prepares rats for dissection in class. In the mid-1970s, dissection was discontinued due to student protests, but it was later reinstated and is once again a regular part of the undergraduate curriculum.

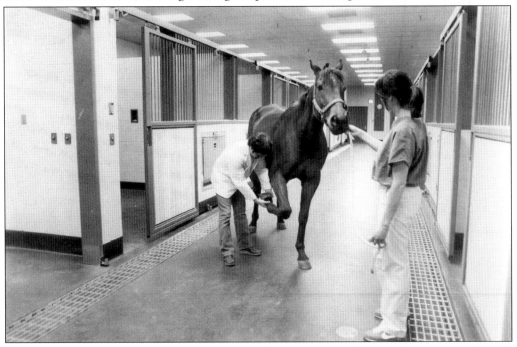

EQUINE EXAMINATION, C. 1981. A veterinarian at the Large Animal Hospital examines a horse's hoof while a student looks on. The Tufts School of Veterinary Medicine, the only such school in New England, opened in 1979. The school is located on a 634-acre campus in Grafton.

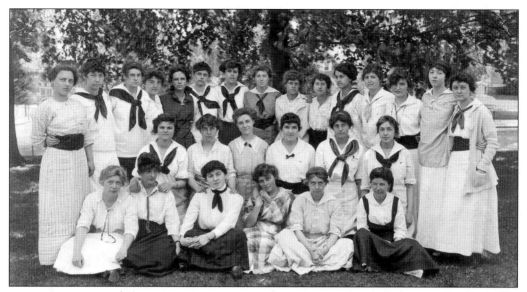

JACKSON FRESHMEN, 1915. This group of incoming freshmen was among the first after a brief experiment with segregation of the sexes at Tufts. From 1910 to 1913, women and men were taught in separate classrooms, used separate study spaces, and had separate chapel services. The experiment was halted when faculty protested at the burdensome duplication of effort this required.

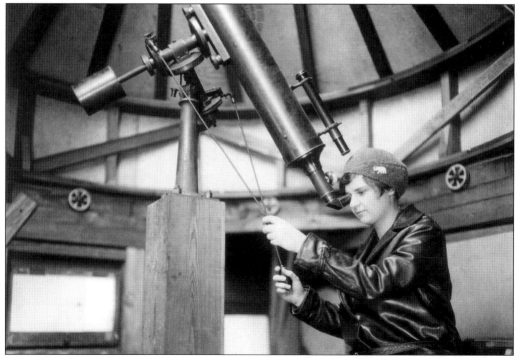

THE TELESCOPE, 1930. In 1925, a small observatory was constructed adjacent to the home of Prof. William Ransom on Sawyer Avenue, on the Medford campus. The Department of Astronomy was founded the same year. Later, a larger observatory was built on the roof of Pearson Chemical Laboratory.

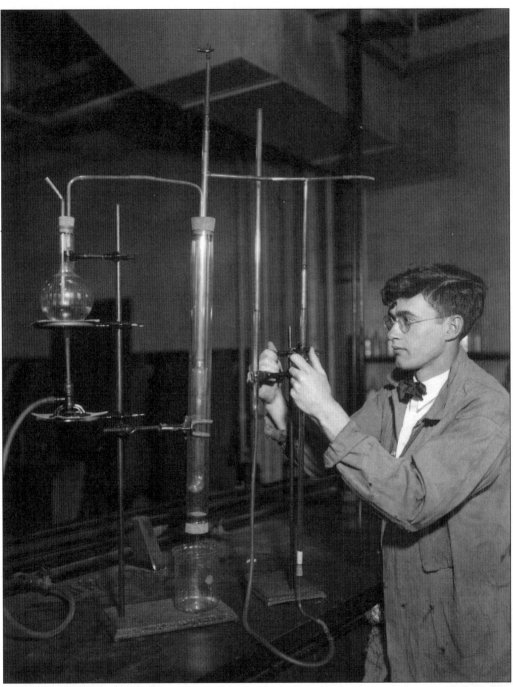

THE CHEMISTRY LAB, *C.* 1930. A student constructs an apparatus for an experiment in chemistry. One of the oldest departments in Arts and Sciences, the Department of Chemistry was founded in 1891. Lab space was originally located in Ballou Hall and then in a temporary structure on Boston Avenue, prior to moving to the Pearson Chemical Laboratory in 1923.

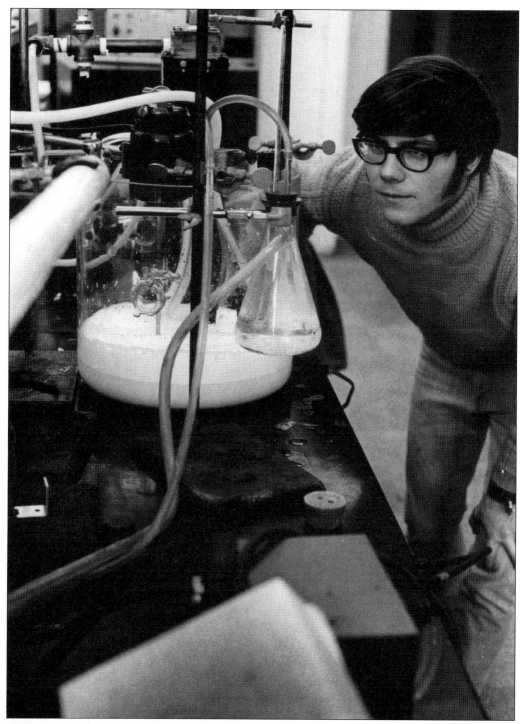

A POLYMER EXPERIMENT, 1970. A student works with polymers in a chemistry lab, most likely located in Michael Laboratory. Constructed in 1964 and attached to Pearson Laboratory, Michael Laboratory, named for department founder Prof. Arthur Michael, provided much needed modern facilities for one of the largest departments in Arts and Sciences.

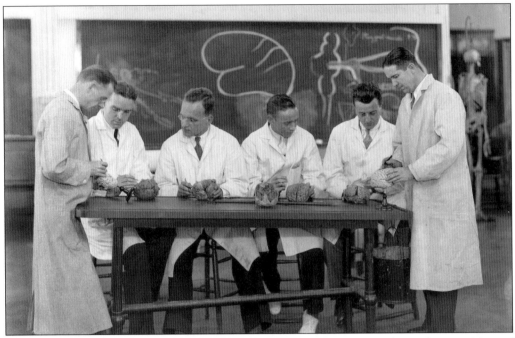

BRAIN DISSECTION, THE MEDICAL SCHOOL, C. 1935. Dissection has always been an integral part of the physiology curriculum of the medical school. Here, students prepare to dissect human brains to learn about the physiology of the human neural system.

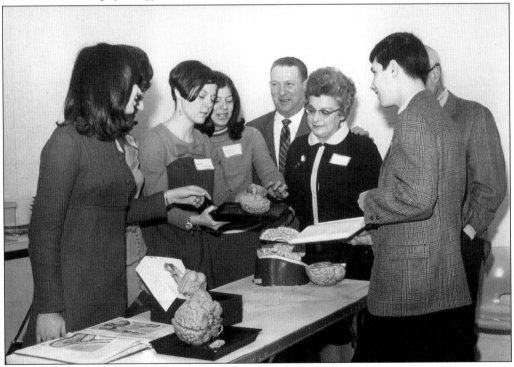

BRAIN PHYSIOLOGY, C. 1968. These students at the Boston School of Occupational Therapy study brain physiology as part of their first-year studies.

THE READING ROOM, 1892. President Capen, wearing his top hat, reads a newspaper in the periodicals room of the library in Middle, now Packard, Hall. The first library in Ballou Hall was open only one hour per week, but by the 1880s, it was open during the day while classes were in session, and in 1893, limited evening hours were added.

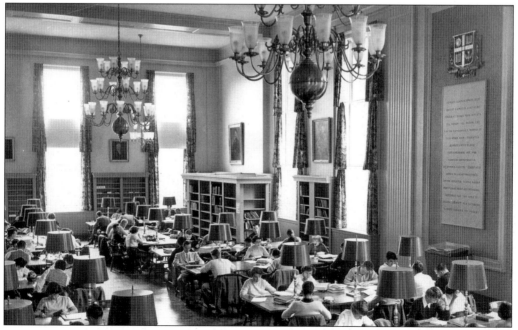

THE READING ROOM, EATON LIBRARY, c. 1950. The War Memorial Wing, containing this reading room, was added to Eaton Library in 1950, nearly doubling its size. The reading room contained plaques dedicated to the 102 Tufts students and alumni who lost their lives in World War II. Visible in the upper right is the coat of arms that was in use in the mid-20th century, alongside the more familiar college seal.

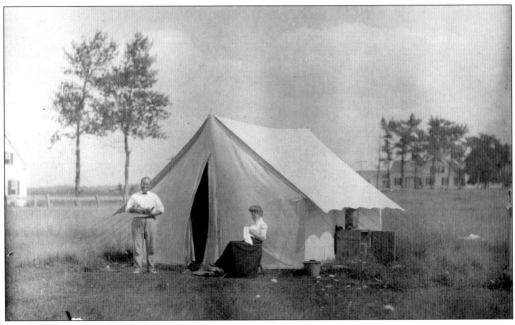

PROFESSOR LAMBERT IN THE FIELD, C. 1910. Fred Dayton Lambert of the Department of Biology was one of the faculty to take advantage of the Harpswell, Maine laboratory for summer research. Pictured here with his wife, also a biologist, Lambert relaxes in front of one of the tents used to provide additional accommodations during the busy summer months.

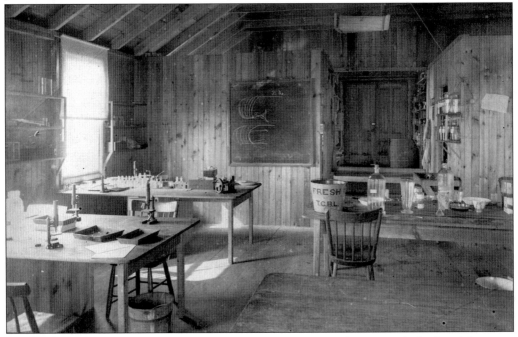

THE TUFTS COLLEGE BIOLOGY LAB, C. 1910. From 1898 to 1913, Tufts operated a biology laboratory on the seacoast in Harpswell, Maine. During the summers, students and faculty would conduct experiments in marine biology. The laboratory was under the direction of Prof. John Kingsley of the biology department.

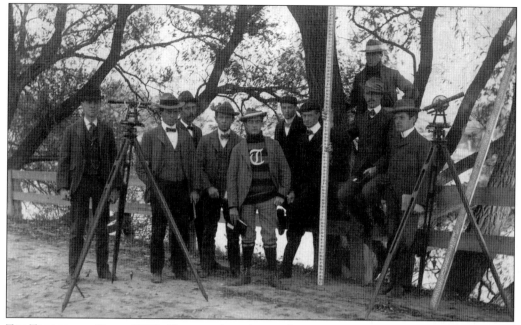

THE TOPOGRAPHY CLASS, 1900. These engineering students were out gaining practical experience in surveying and topography in the fall of 1900. Fieldwork was a central part of the course of studies in engineering, and students were frequently seen around campus and in the local community participating in practical projects.

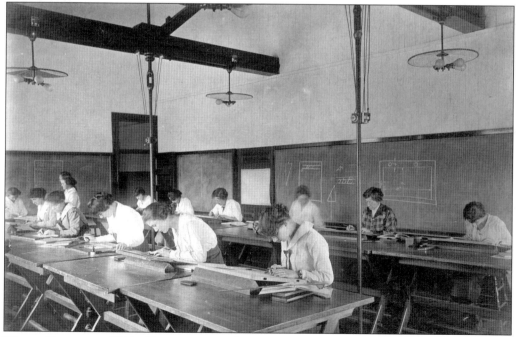

WOMEN ENGINEERS, 1918. The pressures of wartime created opportunities for women on the home front. This group of Jackson students was the first to be allowed to enroll in classes at the engineering school, specifically in drafting. A woman did not, however, receive a degree in engineering until 1943, again during wartime.

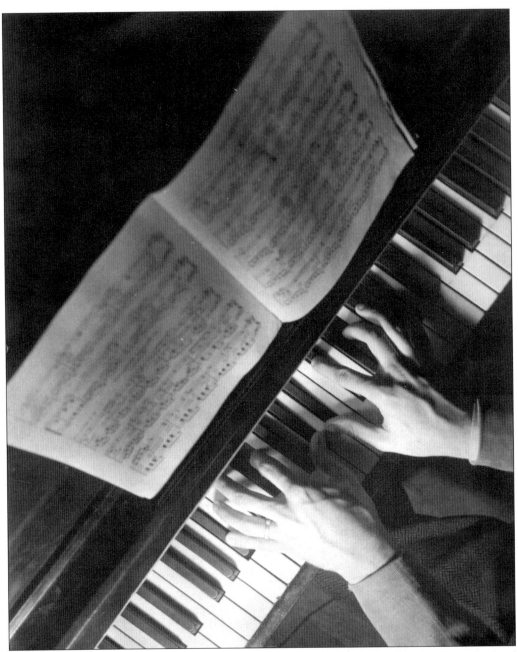

PIANO, *C.* **1980.** In 1977, a dual-degree program was established with the New England Conservatory of Music, in which students received a degree from Tufts and a degree from the conservatory in musical performance after five years of study.

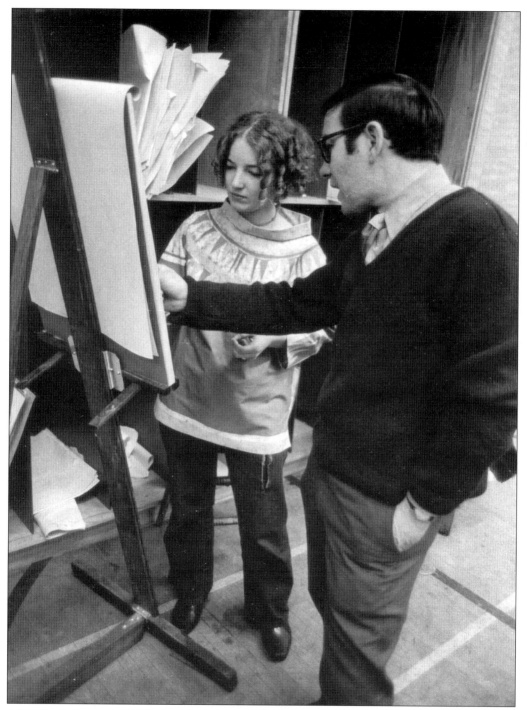

A STUDIO ARTS CLASS, 1970. A student receives instruction in drawing during the 1970 summer session. Fine arts have been a part of the Tufts curriculum since 1899. In 1945, an affiliation agreement was made between Tufts and the School of the Museum of Fine Arts in Boston. Students in the program obtain a B.A./B.S. from Tufts and a B.F.A. from the museum school after five years of study.

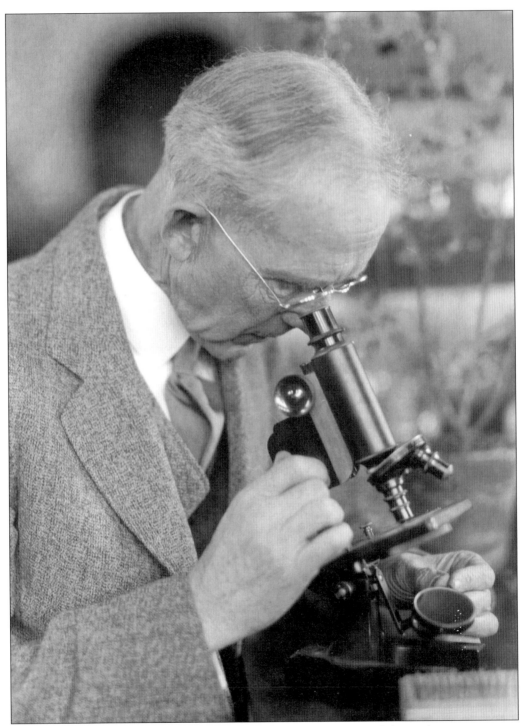

PROFESSOR NEAL AT THE MICROSCOPE, C. 1929. Prof. Herbert Neal of the Biology Department examines a specimen under his microscope. In addition to teaching biology, Neal was also curator of the Barnum Museum. The museum had a large natural history collection, much of which was donated by P.T. Barnum.

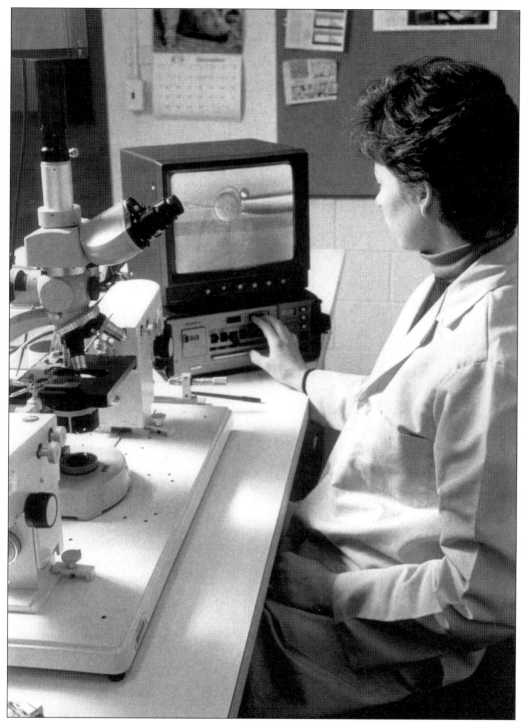

A Research Lab, c. 1985. A researcher at the Sackler School of Biomedical Sciences performs experiments with a single cell. The Sackler School was established in 1980 to coordinate research and training in the health sciences at Tufts and advanced education in biomedical sciences.

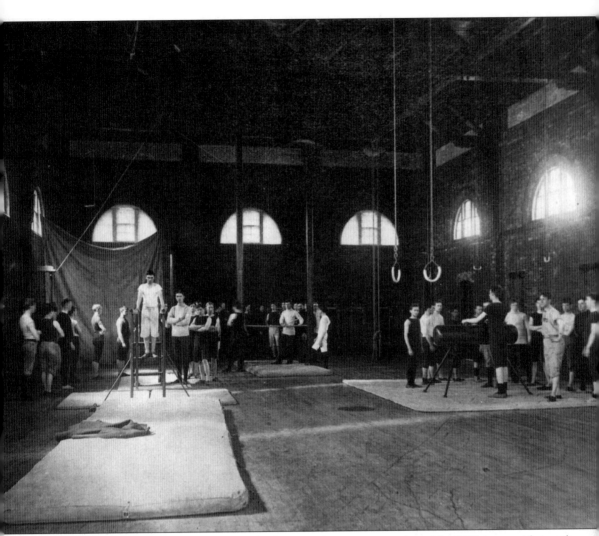

GODDARD GYMNASIUM, C. 1895. Goddard Gymnasium was constructed in 1893 to provide much needed athletic facilities. The original structure, pictured here, was very basic, merely providing a large open space for gymnastic activities. A baseball cage and mezzanine-level running track were added later. Goddard Hall, as it is now known, is one of the main buildings housing the Fletcher School of Law and Diplomacy.

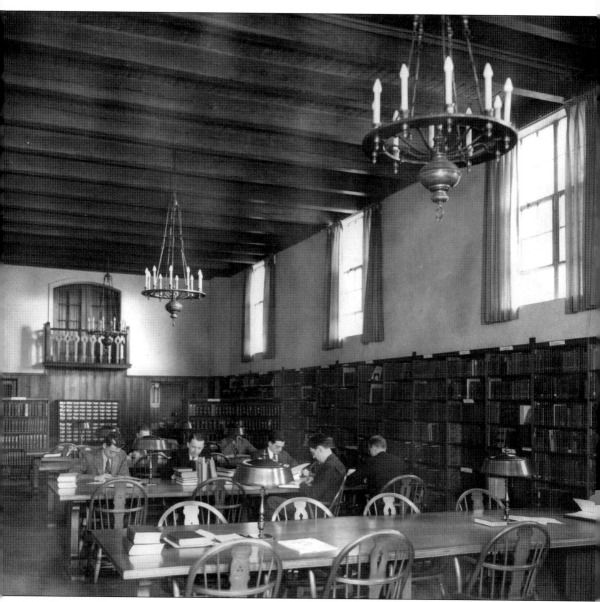

The Reading Room, Fletcher School Ginn Library, *c.* 1935. The Fletcher School's library is named for Edwin Ginn, A1862, publisher and founder of the World Peace Foundation. Ginn donated funds and materials to establish the library when the Fletcher School opened in 1933. Fletcher took over the old Goddard Gymnasium, and the reading room was the old batting cage.

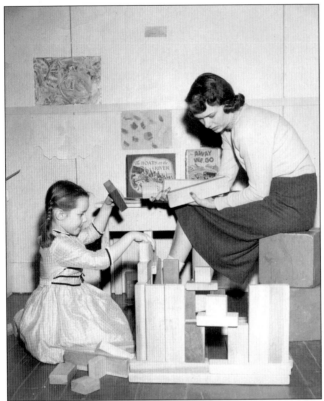

THE ELIOT-PEARSON CHILDREN'S SCHOOL, 1957. The Eliot-Pearson Children's School was established in 1926 and was the first in the country to provide specialized training for nursery school teachers. It was affiliated with Tufts in 1951. Named for its founders, Abigail Eliot and Mrs. Henry Greenleaf Pearson, the school is a laboratory in which Tufts students gain hands-on experience.

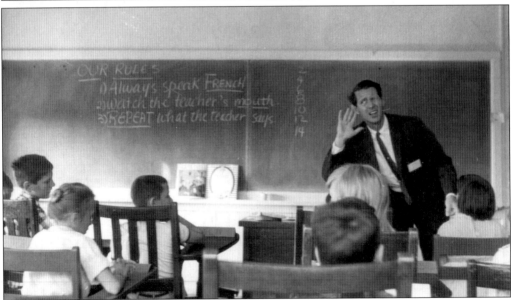

THE CHILDREN'S SUMMER SCHOOL, c. 1965. An instructor in French works with younger pupils in a special summer program on the Medford campus. The educational needs of students from early childhood through the 12th grade continues to be an important part of Tufts's mission through programs that bring young students to the university for unique learning opportunities in science, engineering, theater, and the arts.

32

COLLEGE AVENUE, c. 1913. This view of College Avenue shows Miner and Paige Halls at the top of the Hill. Memorial Steps and the Fischer Arcade were not yet built, nor Crane Chapel. The steep slope down to College Avenue at this time was called the Cut. When this photograph was taken, Jackson College occupied both Miner and Paige Halls.

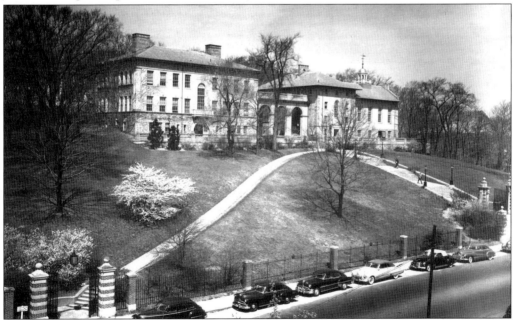

THE CRANE THEOLOGICAL SCHOOL, 1963. Headquartered in Miner and Paige Halls, the Crane Theological School prepared ministers in the Universalist faith, though it accepted students of other beliefs. Anxious to avoid the appearance of sectarianism at Tufts College, but mindful of calls for a school to prepare Universalist ministers, the trustees established the school as a separate division of the college. The school was closed in 1968 due to declining enrollments.

33

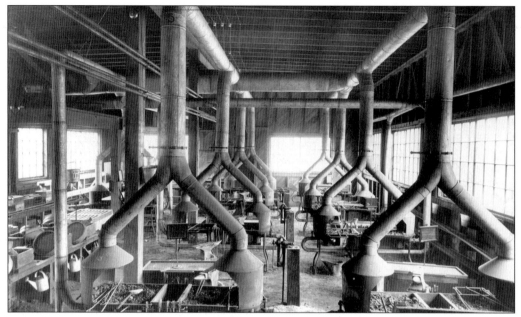

THE FOUNDRY, c. 1904. Engineering was one of the fastest growing areas of enrollment in the early 1900s. By 1904, it was necessary to dramatically expand the powerhouse used to power the engineering labs and classrooms in Bromfield Pearson and Robinson Halls. Part of the addition was this large foundry, where students could cast machine parts for class projects.

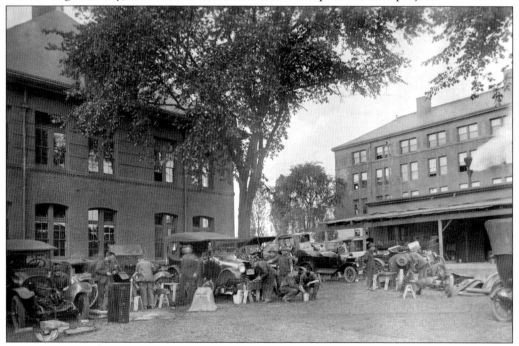

THE AUTO LABORATORY, c. 1918. During World War I, as part of preparedness training for students, the space between Bromfield Pearson on the left and Robinson Hall on the right was used for an automobile laboratory. Students received instruction in basic vehicle repair and maintenance in anticipation of their possible shipment overseas.

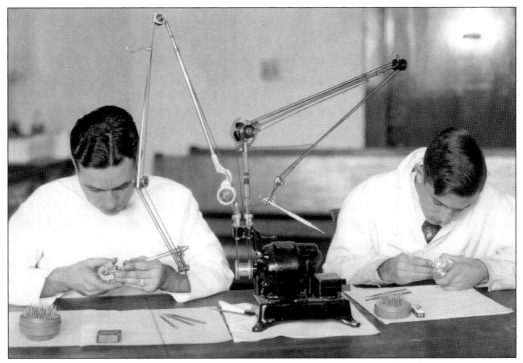

A DENTAL DRILL, 1933. Dental students practice with a new dental drill. When the School of Dental Medicine was founded in 1899, only a high school education was required. By 1927, admission requirements were raised to a bachelor's degree. Students pursued a four-year course of study for a D.M.D. degree.

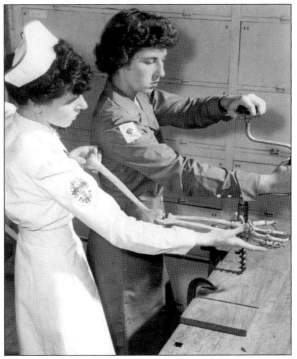

OCCUPATIONAL THERAPY, 1945. The Boston School of Occupational Therapy, one of the first of its kind in the country, was founded in 1918 and affiliated with Tufts in 1945. A supervisor and trainee at the school analyze the arm movements necessary to operate a hand drill.

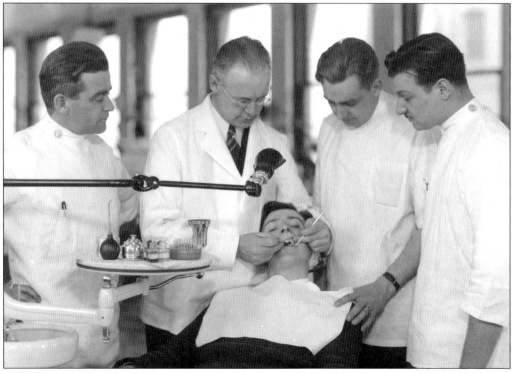

CLINIC DEMONSTRATION, *c.* **1932.** Dental students observe a clinical exam at the dental school. The school's infirmary served more than 100 patients a day for little or no charge, providing a badly needed public service while exposing students to all kinds of clinical material.

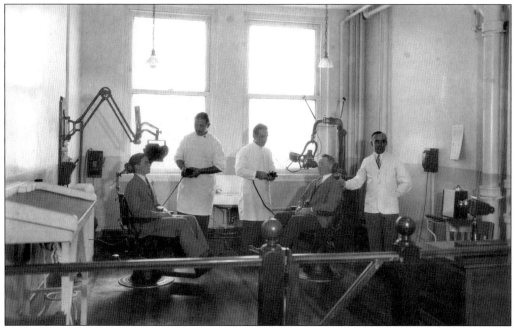

THE X-RAY ROOM, *c.* **1935.** Patients are x-rayed in the infirmary at the dental school. Note the absence of protective shielding both for the patients and the technicians.

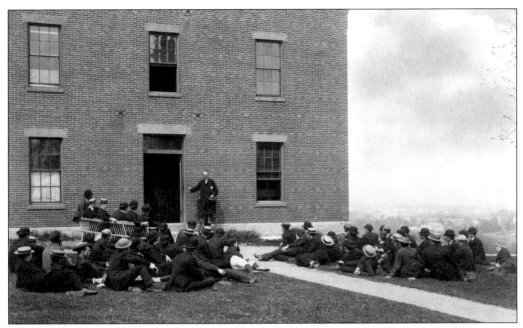

A VISITING SPEAKER, 1885. In 1885, Daniel Pratt, known as the "Great American Traveler," visited Tufts to deliver a lecture. Pratt, a native of nearby Chelsea, was well known for his visits to eastern colleges and his ebullient style. This picture shows the event in front of Middle, now Packard, Hall. It was attended by more than half of the entire student body.

JOHN HOLMES, 1957. Noted American poet John Holmes, A1929, taught at Tufts for almost 30 years. Throughout his many years at Tufts, Holmes was known for the time and attention he gave his students and was called Tufts's poet. A memorial to Holmes is situated next to Packard Hall, where his office was located.

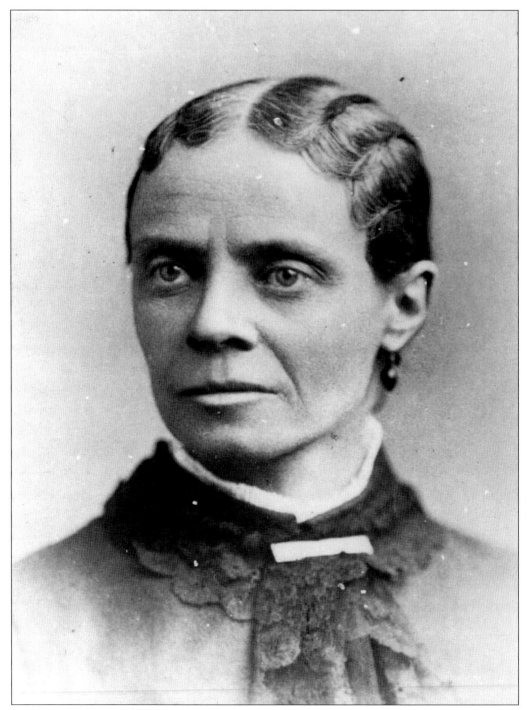

HELEN MELLEN, C. 1884. Mellen was the first full-time librarian at Tufts College. In the original library, President Ballou served as librarian, with a succession of professors and faculty wives maintaining the collection after Ballou's death. By the 1880s, it was clear that the collection needed a full-time librarian, and Mellen, then an assistant in the library, was given the job. In addition to her duties as librarian, she boarded students at her Packard Avenue home.

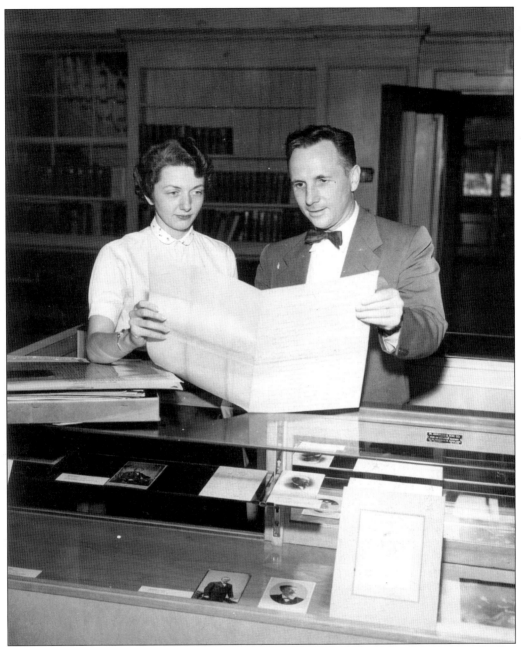

EATON LIBRARY, C. 1950. Two librarians review historical documents in Eaton Library. From meager beginnings in Hosea Ballou's office in Ballou Hall, Tufts libraries had grown by the year 2000 to include one million volumes.

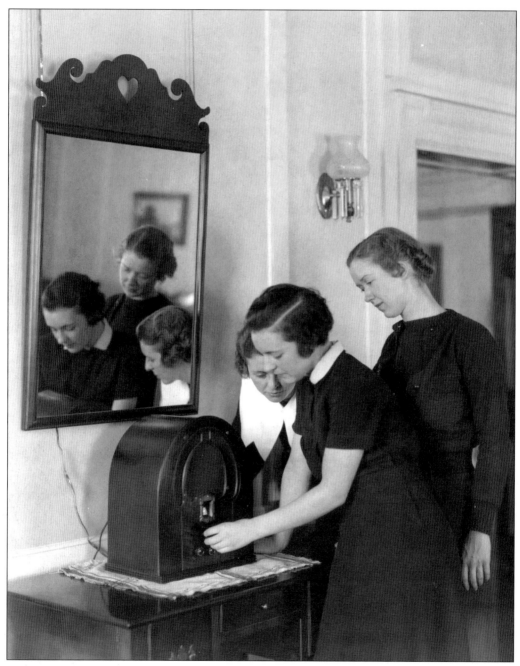

Jackson Dormitory Life, *c.* **1935.** This photograph, entitled "Dormitory life is Attractive!" by photographer Melville S. Munro, shows three Jackson College students in their dormitory. Strict rules governed dorm life for Jackson students, with curfews, requirements for chaperons if going off campus, and limited visiting hours.

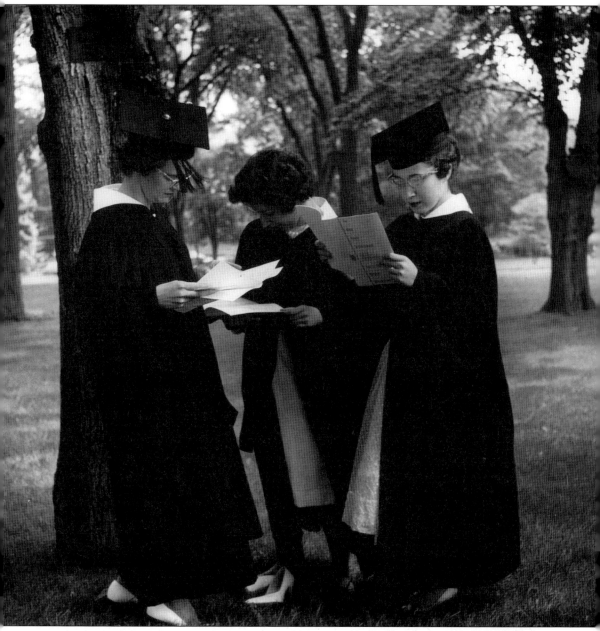

JACKSON GRADUATES, 1961. These Jackson graduates in caps and gowns review the program on commencement day. Since the first enrollment of women in 1892, the place of women in higher education has changed dramatically.

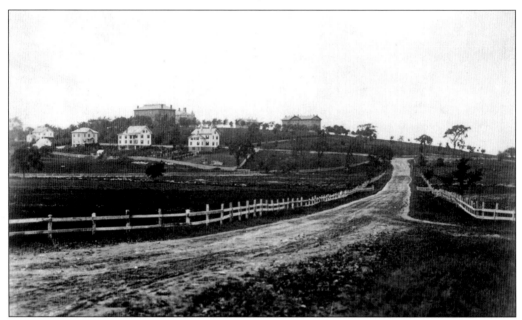

THE HILL, 1875. This view of the Hill taken from Powderhouse Square shows its pastoral setting in early years. Ballou, West, Packard, and East Halls are visible at the top of the hill, with a few faculty residences along Professors Row below. The fields to the left were used for pasturage for faculty cows.

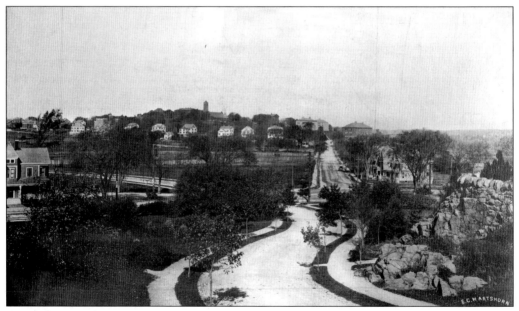

CAMPUS VIEW, 1903. This view of the Hill taken from Powderhouse Park in Somerville shows how much the campus had developed since 1852. The roofs of Barnum, West, Goddard Chapel, East, Miner, Paige, and Robinson Halls are all visible over the trees. Professors Row had its full complement of faculty homes, though the land from there to Powderhouse Boulevard was still undeveloped.

Two

LEADERSHIP

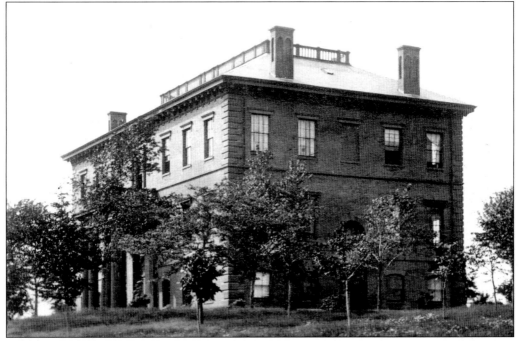

BALLOU HALL, 1875. The first realization of Charles Tufts's vision of a light on the hill was the College Building, now Ballou Hall. With the laying of its cornerstone in 1853, the first college founded by Universalists in the United States began to take physical form.

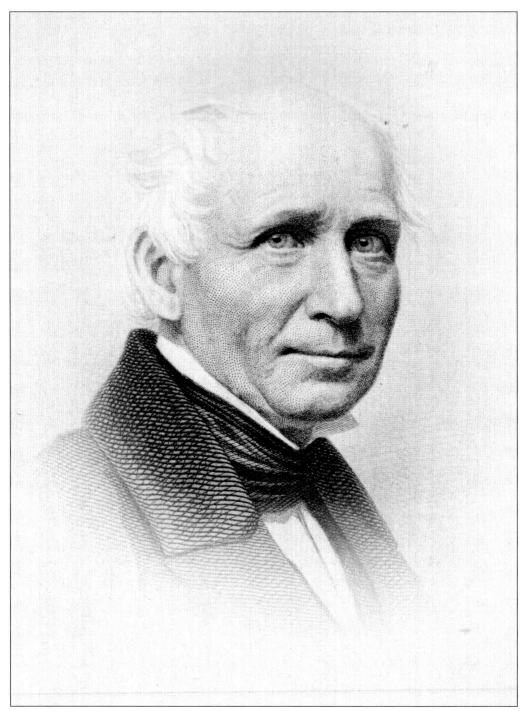

Hosea Ballou 2nd, *c.* **1860.** Ballou, a Universalist clergyman, served as the first president of Tufts College, from 1852 until his death in 1861. Ballou Hall, the first building constructed on the Medford campus, bears his name. In addition to his duties as president and professor of theology, Ballou acted as college librarian, soliciting donations for the collection and personally signing books out to students.

JEAN MAYER, 1983. From the first years of Tufts College to the late 20th century, the duties of its presidents have changed dramatically in magnitude. Jean Mayer, an internationally known nutritionist, led Tufts through a period of remarkable expansion during his term as president, from 1976 to 1992, spearheading the founding of the School of Veterinary Medicine, the School of Nutrition Science and Policy, the Sackler School of Graduate Biomedical Sciences, and the U.S. Department of Agriculture's Human Nutrition Research Center on Aging.

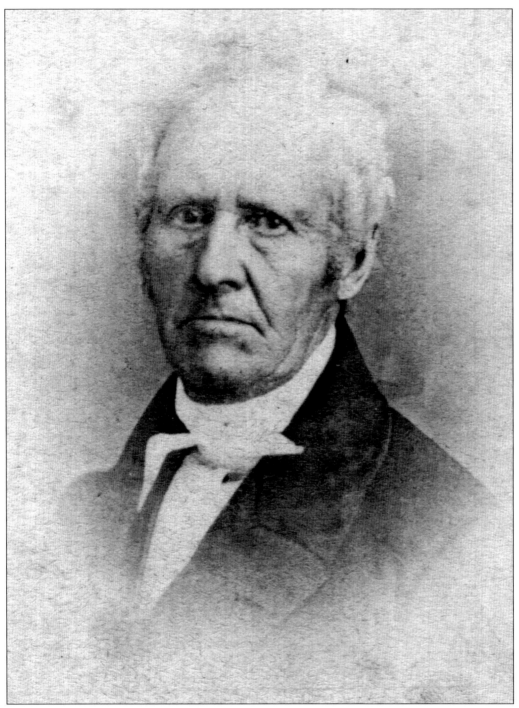

CHARLES TUFTS, c. 1860. Charles Tufts, a wealthy farmer and brick manufacturer, donated the original 20 acres of land where Tufts University is located on the Medford and Somerville line. Walnut Hill dominated the small parcel of land. When asked what he planned to do with the hill, he is said to have replied "I will put a light on it," donating the land to the Universalist Church for the founding of the college that now bears his name.

P.T. BARNUM, c. 1880. P.T. Barnum, showman and circus entrepreneur, was a trustee and benefactor of Tufts College in its early years. An ardent Universalist, Barnum was eager to support the new Universalist school, and in addition to providing funds for the construction of the Barnum Museum of Natural History, his donation of the stuffed hide of his prize elephant, Jumbo, gave Tufts its mascot.

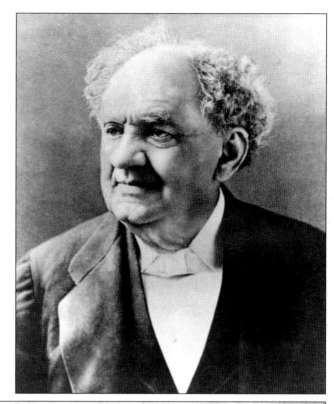

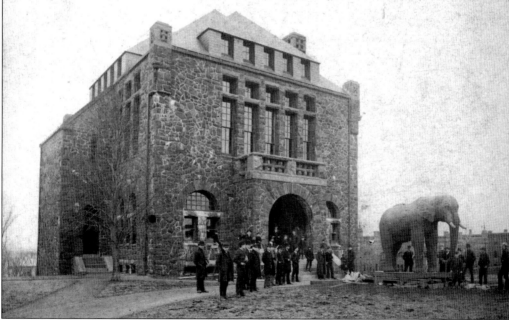

JUMBO'S ARRIVAL AT TUFTS, 1889. After his prized elephant was killed by a train in 1885, Barnum had Jumbo's hide stuffed and his skeleton mounted. In this form, Jumbo continued to tour with the circus until 1889, when the hide was given to Tufts and the skeleton to the American Museum of Natural History in New York.

THE MEDICAL SCHOOL FOUNDERS, C. 1893. The School of Medicine was established in 1893 by seven faculty, who seceded from the College of Physicians and Surgeons in Boston. The group successfully petitioned the president of Tufts, Elmer Capen, to join with Tufts College. When the new school opened its doors it had 80 students and was unusual among medical schools of the day, in that it was coeducational from the start.

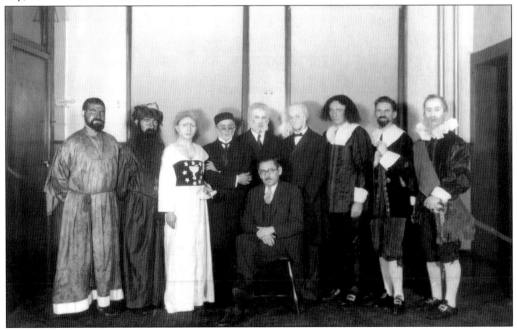

THE MEDICAL SCHOOL FACULTY IN COSTUME, 1930. For many years, it was the tradition of the medical school faculty to dress in costumes portraying prominent figures from the history of medicine while greeting incoming freshmen.

CAROLINE STODDER DAVIES, *c.* **1920.** Davies served as the first dean of Jackson College for Women at Tufts, from 1910 until 1925. She also taught Greek to the women and was an active advocate for women's suffrage.

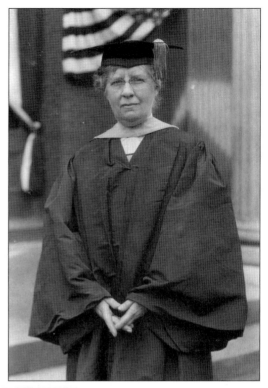

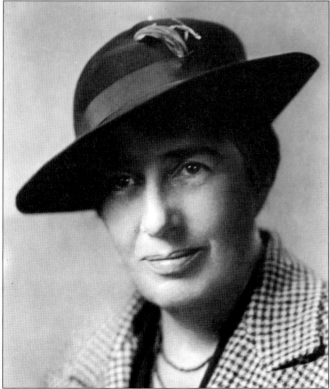

EDITH BUSH, *c.* **1935.** Edith Bush, W1903, H1942, was the second dean of Jackson College, from 1925 to 1952, and the first female professor in the College of Engineering. She taught mathematics at the engineering school in addition to her duties as dean. Her brother, acclaimed scientist Vannevar Bush, was also a Tufts graduate.

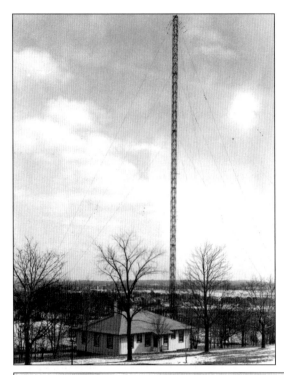

THE NORTH HALL RADIO TOWER, 1915. North Hall was originally the home of AMRAD, a radio research company owned by Harold Power, A1914. Located behind West Hall, the tower pictured here was used for AMRAD's pioneering radio broadcasts.

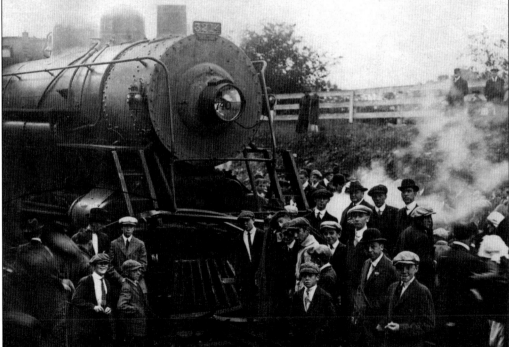

THE TOPPLED RADIO TOWER, 1915. High wind gusts, which struck before the guy wires were put in place to steady the 300-foot radio tower, caused it to crash across the train tracks in the path of the Montreal–Boston Express. The wreckage of the tower is visible across the front of the train. The crash attracted local residents and Tufts students.

AN EARLY RADIO BROADCAST, 1921.
Dean Anthony of the College of
Engineering was among the faculty
members to deliver lectures as part of
the Tufts College Radiophone Series
broadcast on WGI. WGI, which
broadcast out of North Hall on the
Medford campus, was among the first
radio stations in the country to offer
regularly scheduled broadcasts.

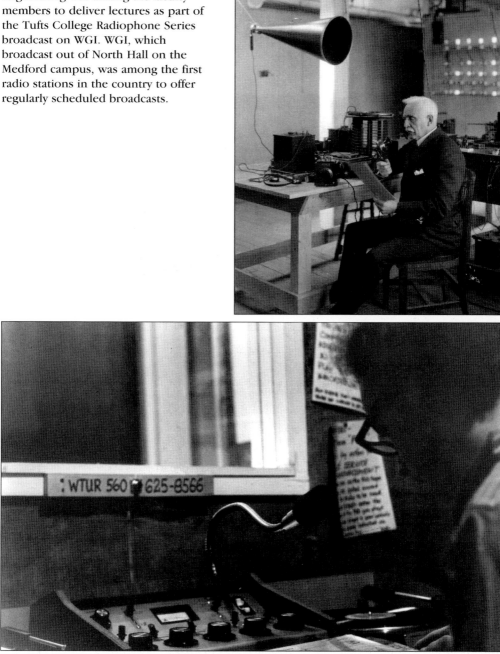

WTUR, c. 1967. Radio station WTUR was established in 1967 as the successor to a long line of student-run radio stations. Its programming consisted of music and Tufts-related news and events. Its immediate predecessor, WTCR, went off the air when the FCC discovered that the military surplus equipment they were using emitted low levels of radiation. WMFO, Tufts's current student-run radio station, began in 1972.

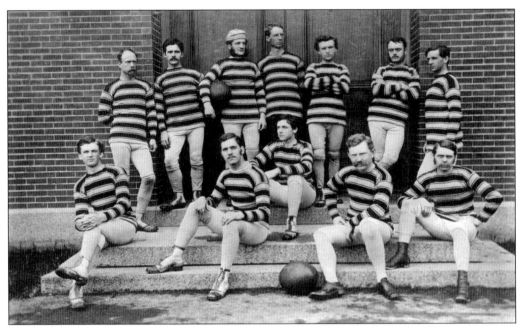

FOOTBALL, 1875. One of the first football teams shows their newly distinctive uniforms. The first game played against Harvard in June 1875 is claimed by many to be the first college football game. Tufts won, scoring the only touchdown and goal. In subsequent years, games were played sporadically against other New England schools, but wide variations in rules made such matches challenging.

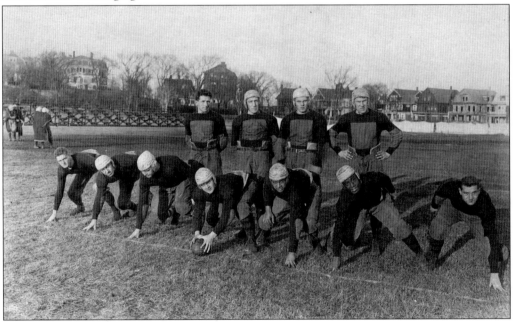

FOOTBALL, C. 1914. Tufts's football program has registered a number of important firsts in its history. The first use of the long forward pass was by a Tufts team in 1912, as was the first use of a huddle in 1916. In 1902, Tufts send its first representative to the All-American college team and the undefeated team of 1934 had three All-Americans.

CAPEN HOUSE, 1876. Capen House was constructed in 1876 to serve as the president's residence on campus. It was named for Elmer Capen, president of Tufts from 1875 to 1905 and first resident of the house. It was later converted into a dormitory for women students and today is the home of the African American Center.

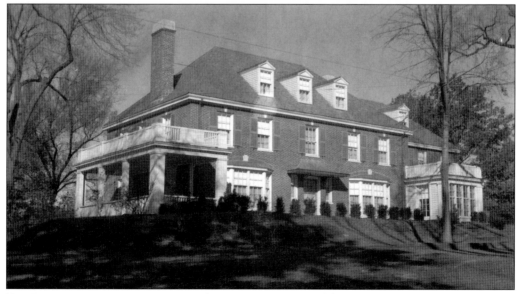

THE PRESIDENT'S HOUSE, 1938. A new home was constructed for Pres. Leonard Carmichael when he took office in 1938. Located on Packard Avenue very close to where Hosea Ballou's house once stood, the president's residence, now called Gifford House, has been home to every president since then.

"Fish" Ellis, 1938. Fred "Fish" Ellis, A1929, was the first athlete at Tufts to letter in four varsity sports. He later returned to Tufts to serve as chair of the Department of Physical Education and director of intramural sports. Ellis Oval on the Medford campus was named in his honor.

"Pop" Houston, 1929. Clarence P. Houston, A1914, was known as Pop to many generations of Tufts students. He was professor of law and economics in addition to serving as athletic director, vice president, and director of alumni relations. President of the National Collegiate Athletic Association (NCAA) from 1955 to 1957 and a member of the U.S. Olympic Committee, Houston donated his house on Talbot Avenue on the Medford campus to be used as the home of the Office of Alumni Relations.

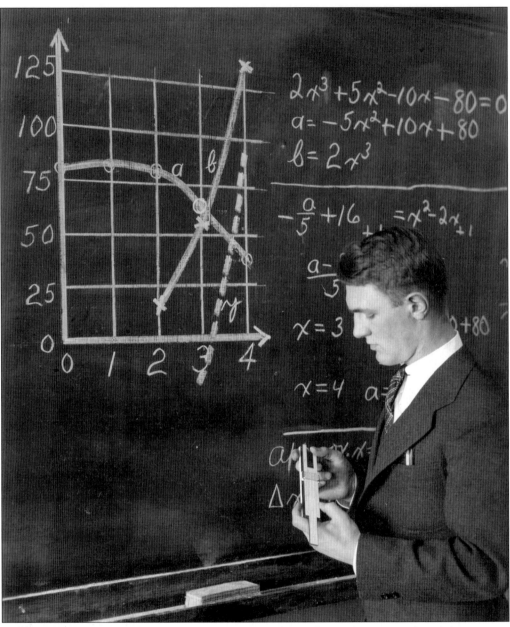

A SLIDE RULE, C. 1930. Slide rules were indispensable tools for students in math and the sciences before the advent of electronic calculators and computers.

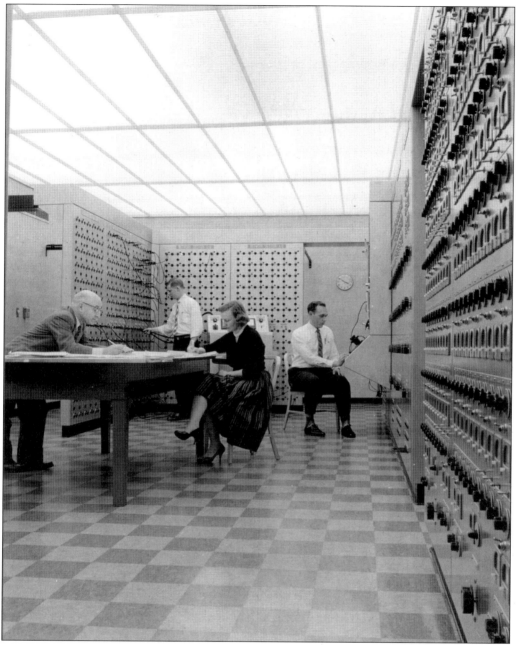

AN ANALOG COMPUTER, 1958. This analog computer, a McIlroy Fluid Network Analyzer, was installed in Bray Laboratory for the Department of Mechanical Engineering. The gift of a group of local natural gas utilities, it was designed to study gas distribution systems.

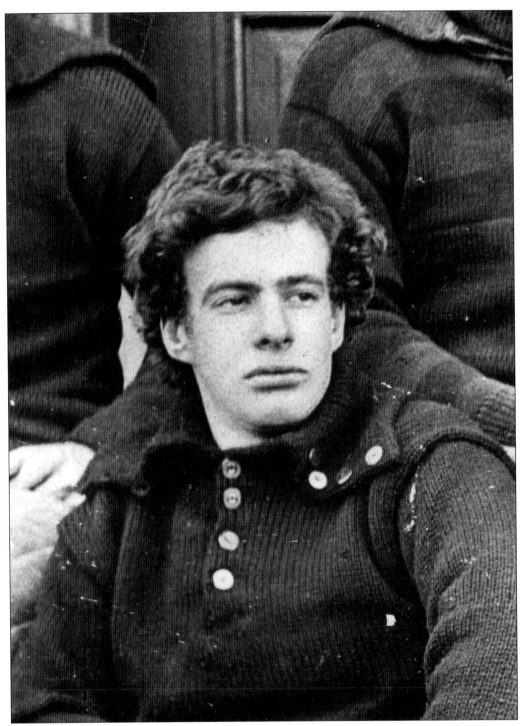

JOHN ALBERT COUSENS, C. 1898. Pictured here with his teammates as an undergraduate, John Albert Cousens would return to serve as president of his alma mater. While president, Cousens took a personal interest in the well-being of Tufts students, assisting many with encouragement and support, including financial assistance, when necessary.

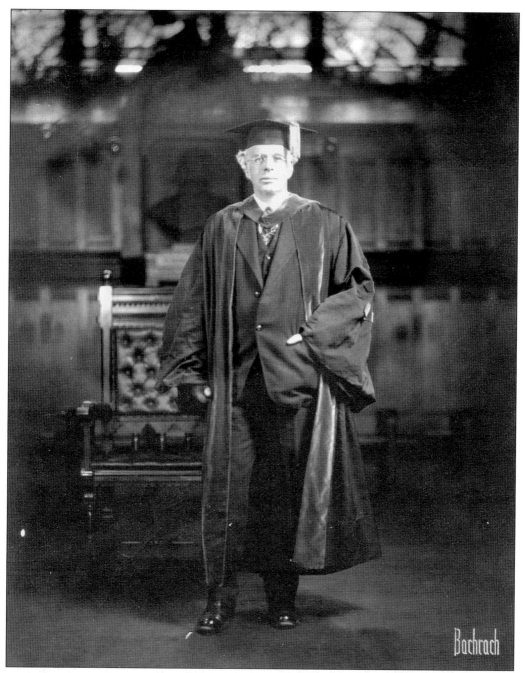

JOHN ALBERT COUSENS, *c.* **1937.** President Cousens poses in full academic robes in Goddard Chapel. As president from 1920 to 1937, Cousens saw the college through the difficult years of the Great Depression and was instrumental in the establishment of the Fletcher School of Law and Diplomacy and the New England Medical Center. He died while still in office in 1937.

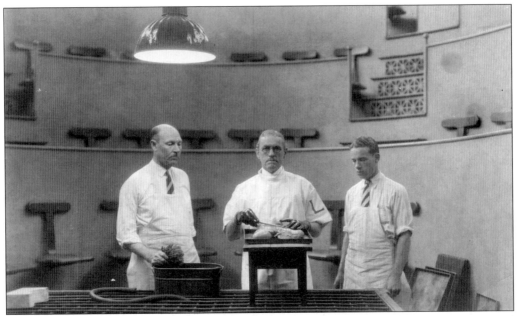

A PATHOLOGY DEMONSTRATION, *C.* **1920.** Dr. Timothy Leary, professor of pathology in the medical school, prepares for a demonstration in the Boston City Hospital amphitheater. Leary served on the Tufts faculty for more than 30 years and was widely acclaimed for his work in smallpox immunization and the development of a vaccine for pneumonia.

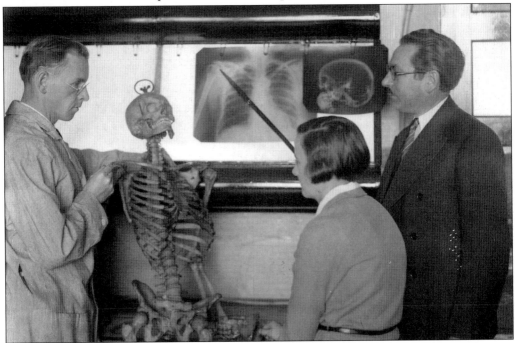

MEDICAL SCHOOL DEMONSTRATIONS, *C.* **1930.** An examination of the anatomy of the shoulder joint with an x-ray and skeleton. The Tufts School of Medicine was the only medical school in New England that was coeducational from its inception. As a result, for many years enrollment at Tufts became the single option available to area women interested in becoming doctors.

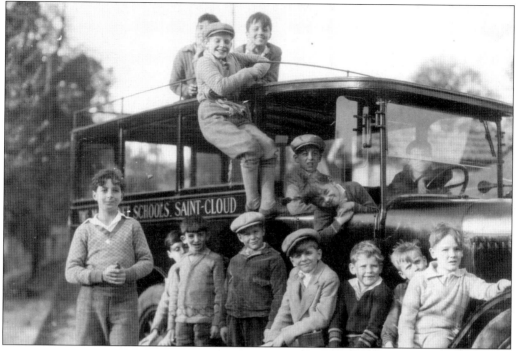

A MacJannet School Trip, c. 1924. Charlotte and Donald MacJannet, A1916, ran a series of schools and camps in France, beginning in 1923. Located just outside Paris in St. Cloud and the alpine village of Talloires, the programs attracted the children of American expatriates and members of the diplomatic corps of many countries.

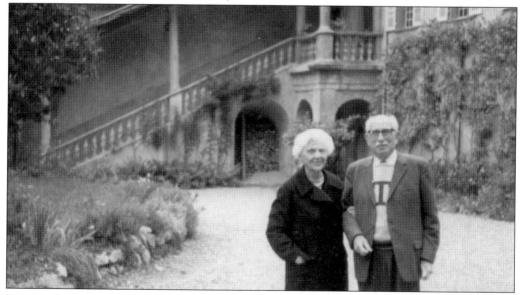

The Priory, c. 1978. The MacJannets pose in front of the 11th-century priory they donated to Tufts to serve as the university's European Center and fourth campus. Located in Talloires, in the French Alps, the European Center hosts an array of summer study programs and conferences. The center served as the headquarters of the U.S. Olympic Committee during the 1992 Olympic Games in Albertville.

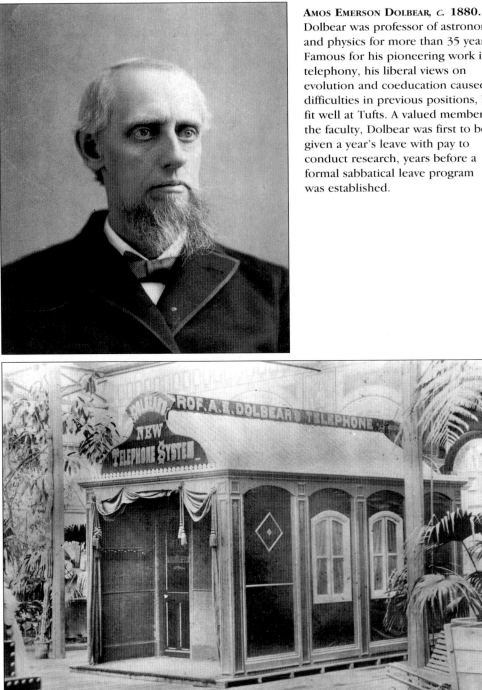

AMOS EMERSON DOLBEAR, C. 1880. Dolbear was professor of astronomy and physics for more than 35 years. Famous for his pioneering work in telephony, his liberal views on evolution and coeducation caused difficulties in previous positions, but fit well at Tufts. A valued member of the faculty, Dolbear was first to be given a year's leave with pay to conduct research, years before a formal sabbatical leave program was established.

AT THE CRYSTAL PALACE EXHIBITION, 1882. Amos Emerson Dolbear exhibited his telephone at one of the Crystal Palace Expositions in London. At the time, Dolbear was deep in litigation against Alexander Graham Bell and his telephone company over patent rights to early telephone technology. Ultimately, the case went to the Supreme Court, where Dolbear lost. However, he is still believed by many to be the inventor of the telephone.

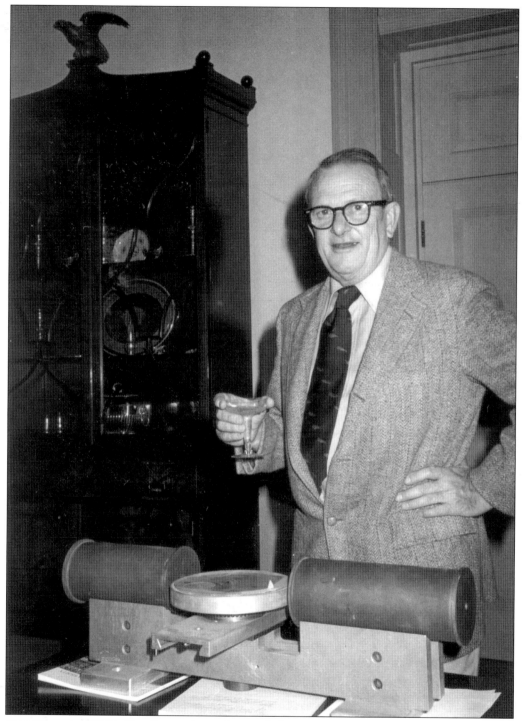

ALAN CORMACK, 1979. Alan Cormack, professor of physics, was awarded the 1979 Nobel Prize in Medicine for his work on the development of the CAT scan, the only faculty member in Tufts history to receive this award. Here, Professor Cormack stands beside an early model of the CAT scan, celebrating the announcement of his win.

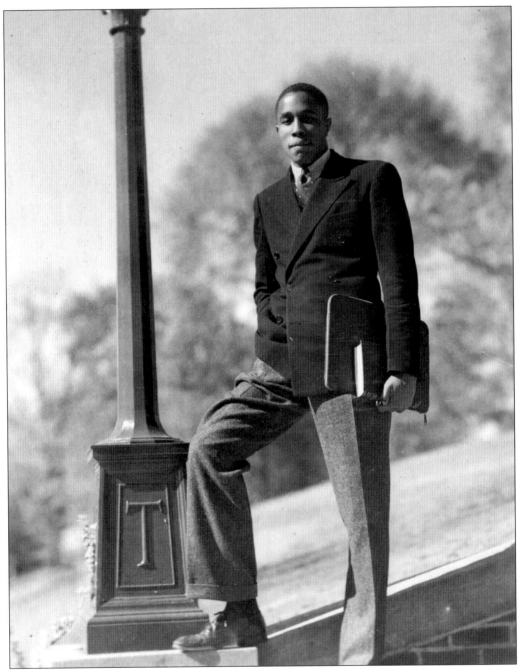

EDWARD DUGGER, 1938. As well as being one of Tufts's most accomplished athletes, Eddie Dugger was an outstanding student in the College of Engineering and a member of Tau Beta Pi, the national engineering honor society. One of a number of pioneering African Americans at Tufts, Dugger followed in the footsteps of Forrester Washington, A1909, the first identified African American graduate of the College of Liberal Arts, and Madeline Bernard, J1920, of Jackson College.

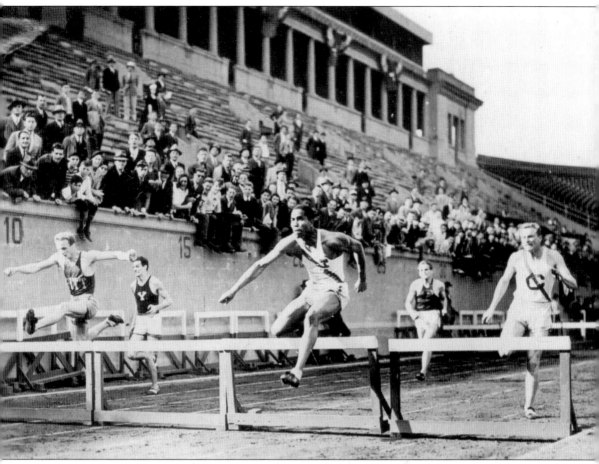

EDWARD DUGGER, 1941. One of the greatest athletes to compete for Tufts, Eddie Dugger wins the 220-meter low hurdles at a meet at Harvard. A versatile athlete, Dugger competed in high and low hurdles, high jump, long jump, and relay. He also played baseball and boxed.

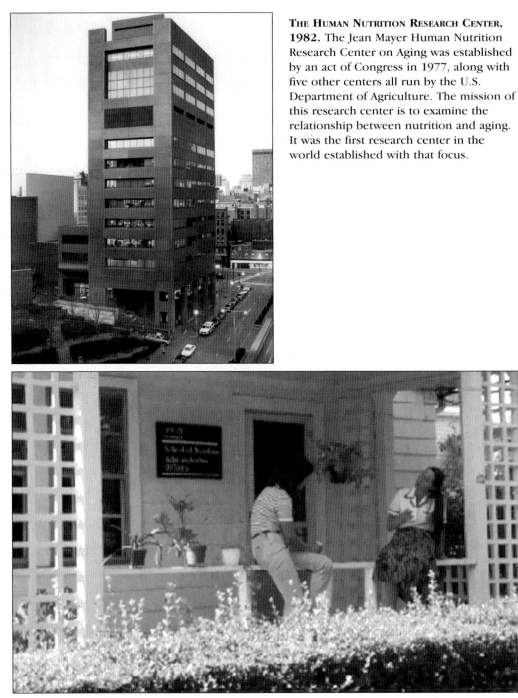

THE HUMAN NUTRITION RESEARCH CENTER, 1982. The Jean Mayer Human Nutrition Research Center on Aging was established by an act of Congress in 1977, along with five other centers all run by the U.S. Department of Agriculture. The mission of this research center is to examine the relationship between nutrition and aging. It was the first research center in the world established with that focus.

THE NUTRITION SCHOOL, C. 1982. The School of Nutrition Science and Policy was founded in 1981 under the guidance of Jean Mayer, Tufts president and world-renowned nutritionist. It was founded to bring together biomedical, social, political, and behavioral scientists to conduct research, educational, and community service programs to improve the nutritional health and well-being of populations throughout the world. Blakeslee House on the Medford campus is headquarters of the school.

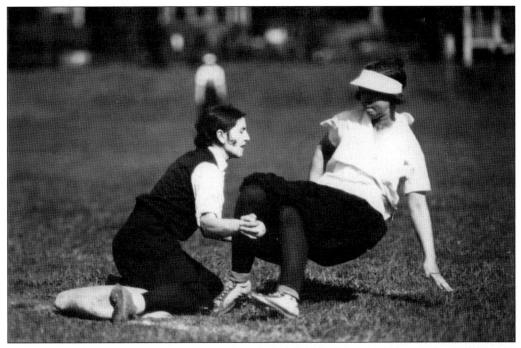

JACKSON VERSUS BROWN, 1929. The first Jackson varsity baseball team was begun in 1929, though baseball was played at Jackson informally long before that. This was the first intercollegiate game they played, against Brown, the only other women's team in the area. Brown trounced Jackson, 25–6, but by the following season, Jackson turned the tables, winning 18–6. Varsity baseball continued into the mid-1930s.

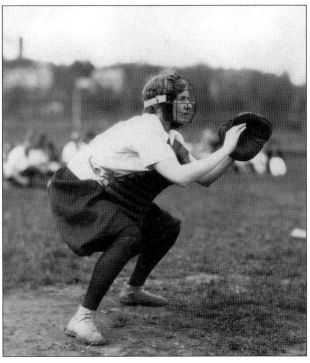

JACKSON VARSITY BASEBALL, 1929. The crouching stance demonstrated by catcher Margaret Reynolds, J1929, was unusual for its time. It was far more common for the catcher to stand well behind the batters to catch balls off a bounce rather than hold such an "unladylike" pose.

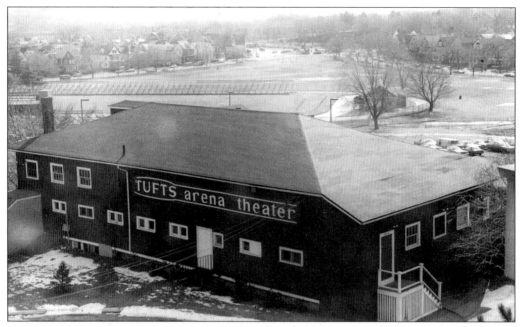

THE ARENA THEATER, 1970. Theater-in-the-round was pioneered at Tufts in 1947 by drama professor Marsten Balch. The theater building was constructed in 1909 as the gymnasium for Jackson College. A new arena theater was incorporated into the Aidekman Arts Center in 1991 and named in Balch's honor.

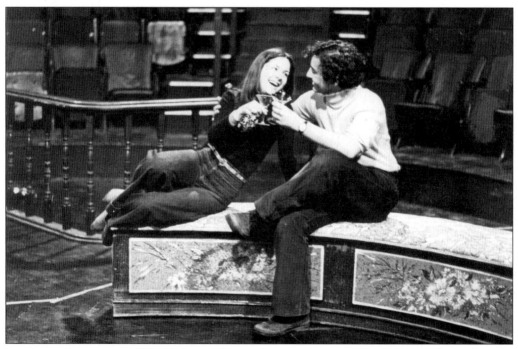

THE ARENA THEATER, c. 1980. Students rehearse for a production of *Barefoot in the Park* in the Arena Theater. When the new Balch Arena Theater was completed in 1991, the old theater building was torn down. A plaque now memorializes its original location.

Three
COMMUNITY CULTURE

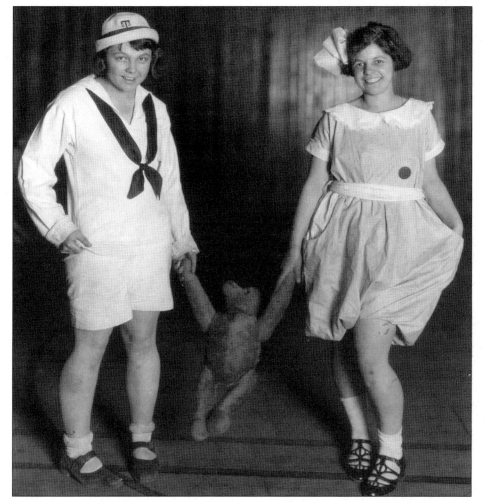

A BABY PARTY, c. 1920. Jackson's baby parties were the culmination of a year of hazing intended to build class and school spirit. At the parties, the freshmen dressed like babies while their sophomore "aunts" admonished them to be good "Jaxonites" and remember all they had learned. The occasions featured the singing of the school songs all students were required to learn by heart. The last known baby party was held in 1954.

FRESHMAN CAPS, c. 1925. For many years, freshmen were required to wear beanies such as those pictured here. As one of numerous freshman traditions, strict rules governed when and how the caps were to be worn. Freshmen were required to touch their caps to passing upperclassmen, and if they lost a class contest, such as a tug-of-war or the Jam, they might be forced to wear their beanies inside out for some time.

BEANIES, 1962. These freshmen in the Class of 1966 sport their class beanies at orientation. By the end of the decade, freshman traditions such as beanies had died out as a result of changing attitudes toward the undergraduate experience. Carmichael Hall is in the background.

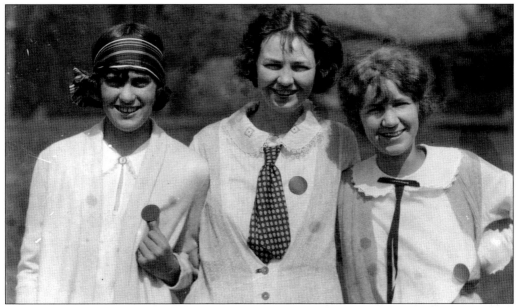

FRESHMAN BUTTONS, C. 1920. These Jackson students show the green button all Jackson freshmen were required to wear. The buttons enabled members of the class to be more identifiable to each other and to others. In 1931, the buttons were replaced by bows after many students complained of the damage buttons did to clothes.

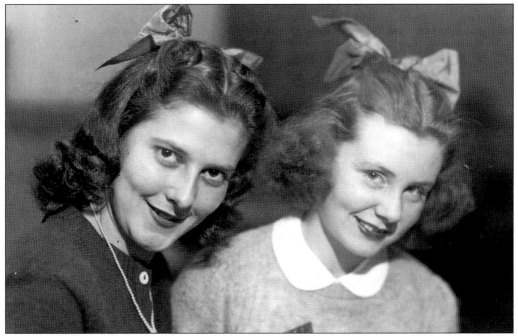

FRESHMAN BOWS, 1940. Part of designated attire for Jackson first-year students was a green bow to be worn at all times. In 1942, a group of freshmen staged a strike, refusing to wear the bows and symbolically ripping them apart in a demonstration on the steps of Eaton Library. The rebels were chastised at a chapel session called specially for the purpose, and bows continued to be worn for a number of years.

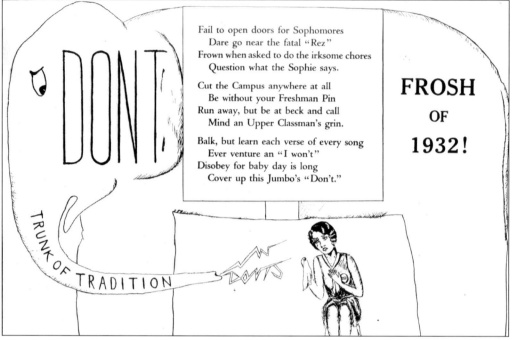

Fail to open doors for Sophomores
 Dare go near the fatal "Rez"
Frown when asked to do the irksome chores
 Question what the Sophie says.

Cut the Campus anywhere at all
 Be without your Freshman Pin
Run away, but be at beck and call
 Mind an Upper Classman's grin.

Balk, but learn each verse of every song
 Ever venture an "I won't"
Disobey for baby day is long
 Cover up this Jumbo's "Don't."

FROSH OF 1932!

FRESHMAN RULES, 1932. This list of rules admonishes Jackson freshmen to open doors for sophomores, learn the verses of school songs, and stay away from the "Rez," as the Reservoir was called. Punishment for breaking the rules was meted out at baby day. The baby parties, as they were called, were a long-standing Jackson tradition.

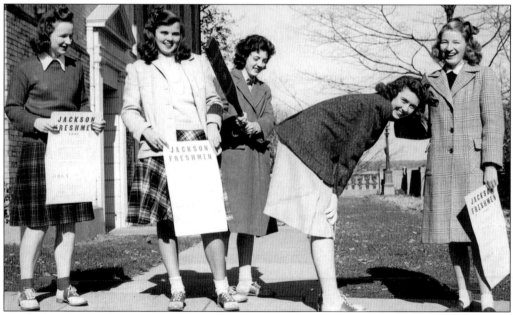

FRESHMAN RULES, 1945. By the 1940s, infractions against the freshman rules were punishable by paddling. Hazing among Jackson students was a regular occurrence, though objections became more vigorous by the late 1950s. Over the course of the 1960s, the hazing was increasingly curtailed and was all but eliminated by 1970.

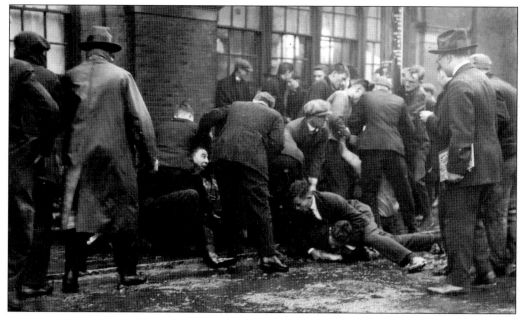

THE JAM, *c.* 1916. The Jam was a tradition begun as early as 1905. Part of the annual banquet season, during which the freshmen and sophomores held banquets for class spirit, the Jams involved each class trying to prevent members of the other from attending its banquet. Jamming involved kidnapping members of the opposite class; victims such as these outside Curtis Hall were ambushed, tackled, and hogtied until the banquet was over.

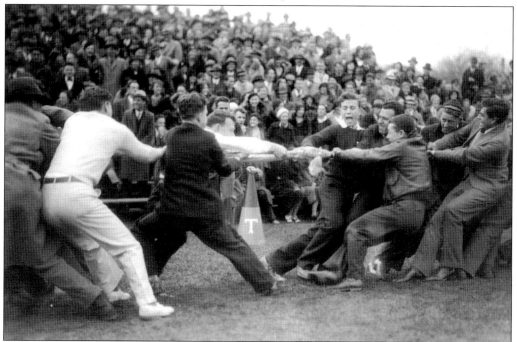

A TUG-OF-WAR, *c.* 1920. A tug-of-war was one of the traditional freshman-sophomore contests. It was held annually at halftime during one of the major football games of the year, while spectators cheered the teams on. The side on the right is the freshman class, as evidenced by the beanies.

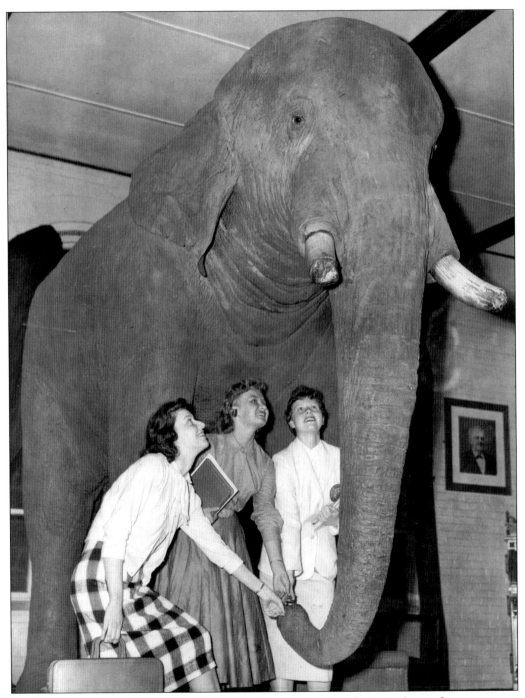

JUMBO WITH JACKSON STUDENTS, *c.* **1954.** Placing pennies in Jumbo's trunk was for many years believed to bring good luck.

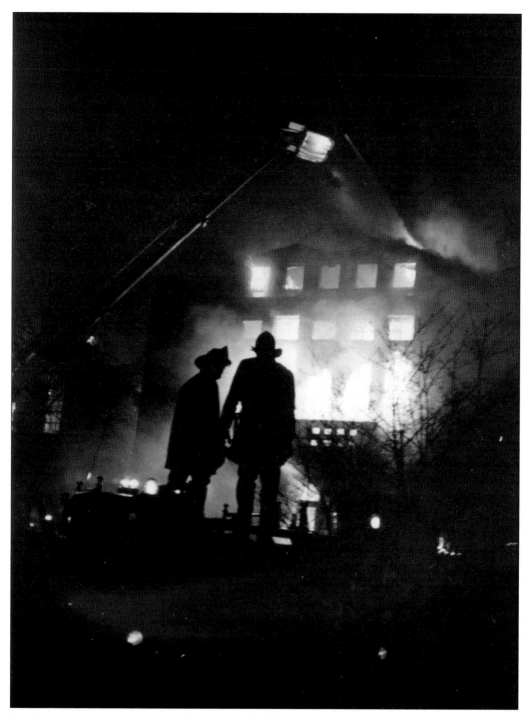

THE DESTRUCTION OF THE BARNUM MUSEUM, 1975. The Barnum Museum was gutted by fire during the night of April 15, 1975, destroying faculty research as well as Jumbo and other Barnum materials. The next morning, the secretary of the athletics department salvaged ashes from where Jumbo had stood, placing them in an empty peanut butter jar. The ashes continue to serve as a good-luck charm for Tufts athletic teams.

CLASS DAY, 1926. The Class Day tradition began in 1876. Held a few days before commencement, it was an opportunity to celebrate the achievements of the graduating class. As the tradition developed over the years, the highlight of the day became the seniors' last chapel, followed by a luncheon.

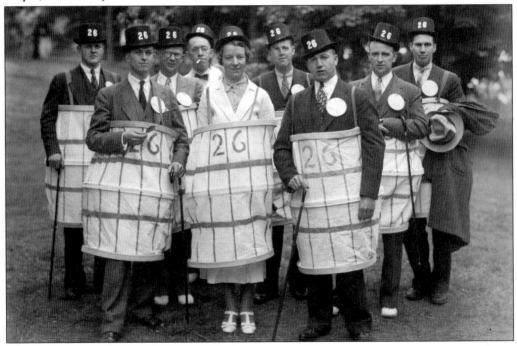

THE 10TH REUNION, 1936. Members of the Class of 1926 gather for the Alumni Day parade on their 10th reunion. Members of reunion classes often dressed in flamboyant costumes for the parade around campus as a celebration of class spirit, though in later years distinctive hats, sashes, or buttons were more common. Tree plantings are another tradition of Alumni Day, and the members of this class gave six cherry trees for their 10th reunion.

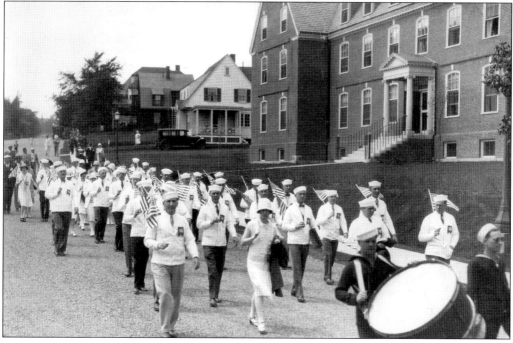

THE CLASS OF 1918, 1928. The Class of 1918 marches in the Class Day parade at its 10th reunion. Stratton Hall, a women's dormitory completed the previous year, is in the background.

CLASS OF 1918, 1968. Back for their 50th reunion, members of the Class of 1918 have swapped sailor hats for berets as they pose for a picture on the President's Lawn.

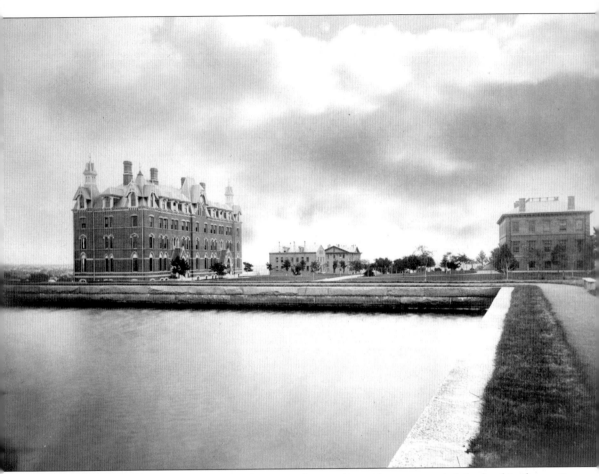

THE REZ, 1883. The Reservoir, or Rez, as it was known by students, occupied the land to the west of the original campus. It was constructed in 1865 to provide water for the surrounding area, but it also played a major role in campus social life. It was said that dates made on the Rez could never be broken. First-year students were periodically dunked in the Rez as punishment for breaking the freshman rules enforced by the sophomore Sword and Shield traditions society. This view of the quad shows West, Packard, East, and Ballou Halls. Barnum Museum was constructed the following year.

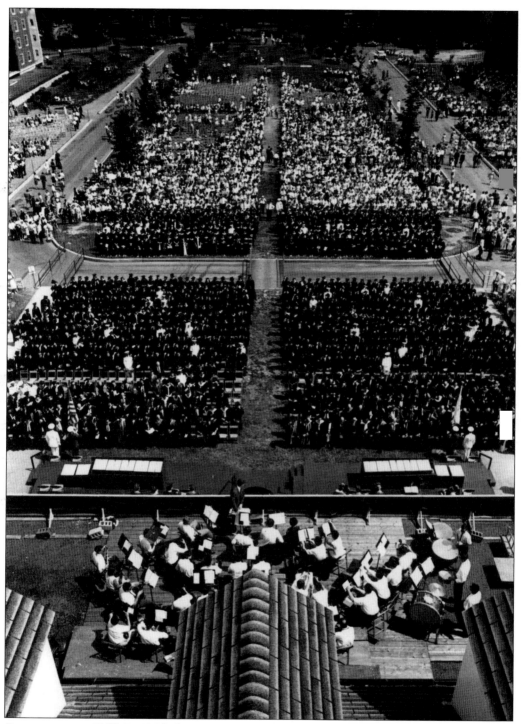

COMMENCEMENT, 1966. In 1954, the university purchased the Reservoir and three years later filled it in to use as a parking lot. The area, now flanked on three sides by dormitories (Miller, Carmichael, and Houston) and the Olin Center, was used for several years for commencement. This view was taken from the cupola on the top of Carmichael Hall.

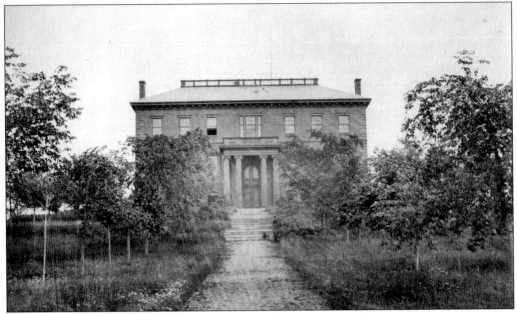

BALLOU HALL, C. 1854. This very early photograph shows Ballou Hall soon after its completion in 1854. Originally called simply College Building or College Edifice, it housed classrooms, the library, laboratories, a museum, administrative and faculty offices, student living quarters, and a chapel.

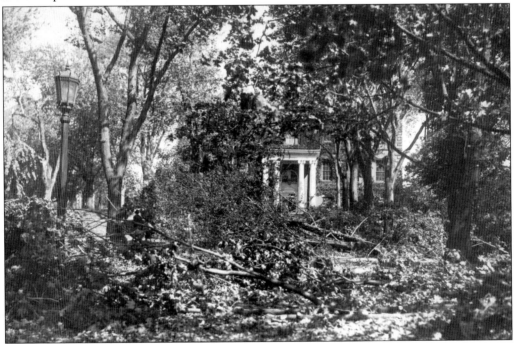

HURRICANE DAMAGE, 1938. The Hurricane of 1938 wreaked extensive damage on many of the stately old trees on the Medford campus. This view shows the path leading to Ballou Hall from Professors Row. The damage done to trees and buildings on campus was so extensive that repairs took more than one year to complete.

THE CLASS OF 1879 BY BALLOU HALL, 1879. The Class of 1879 gathers for a portrait outside the side door of Ballou Hall, then known simply as the College Edifice. Though no longer in use, this entrance on the side of Ballou, facing what is now Goddard Chapel, served as the main entrance.

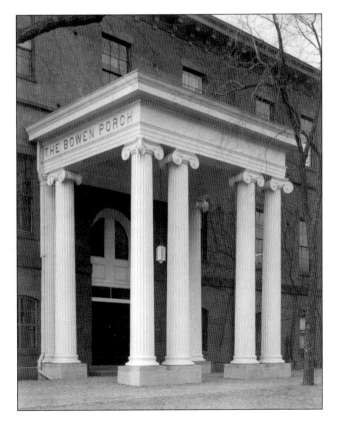

THE BOWEN PORCH, C. 1940. The Bowen Porch was added to the quad side of Ballou Hall in 1939, effectively changing the orientation of the building. The original main entrance faced Professors Row. For many years, however, a side door was used to enter and exit the building. Extensive renovations to the interior of Ballou Hall, including the construction of a formal entrance hall, confirmed the Bowen Porch as the front door.

PROFESSORS ROW, *C.* 1920. Still unpaved, this view of Professors Row shows many old elms later damaged in the Hurricane of 1938. John Holmes, Tufts's poet, wrote a poem titled "Along the Row" describing the experience of strolling the Row on a day such as this. The poem appears on a plaque in the Campus Center, built immediately to the left of where this photograph was taken.

THE ALUMNI GATE AND GODDARD CHAPEL, 1929. This view of Goddard Chapel tower is framed by the Alumni Gate, across from the Campus Center on Professors Row, and one of several gates in the wrought iron fence that encircles the center of the Medford campus. Construction began on the fence in 1924 and was funded by contributions from alumni. At one time the fence enclosed all of the uphill part of the campus.

BUILDING B, c. 1900. One of the oldest structures on the hill, this modest house was constructed in 1857 on the site of West Hall to serve as a boardinghouse for students awaiting the completion of East Hall. Known simply as Building B, it was moved to Professors Row in 1870 to serve as a faculty residence.

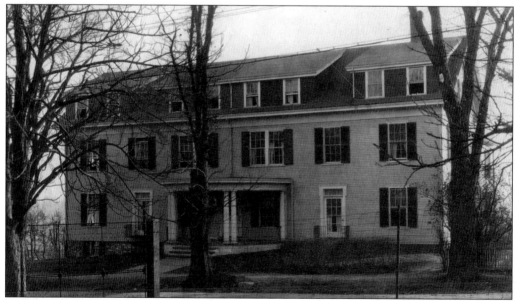

RICHARDSON HOUSE, c. 1920. Building B is still in use today as the western half of Richardson House, a dormitory for women. The size of the structure was doubled in 1910 with the addition of a wing to the east that was the mirror image of the original house. The dormitory was named for Mary A. Richardson, a longtime benefactor of the college. Richardson remains the only single-sex dormitory at Tufts.

84

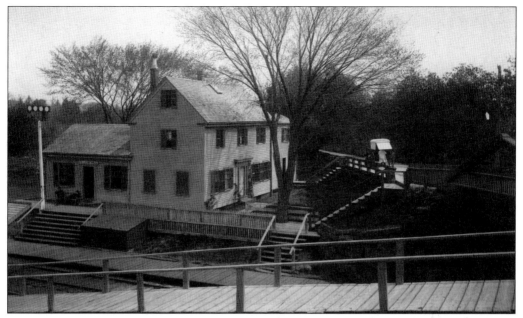

COLLEGE HILL STATION, c. 1895. In the earliest years, the quickest way into Boston was via hired rowboat, down the Mystic River. Rail service made a much more convenient alternative. This station, constructed c. 1860, was the first Tufts railroad station, located on the north side of College Avenue, near where Halligan Hall now stands. Travelers could reach Boston in a matter of minutes, and trains ran frequently.

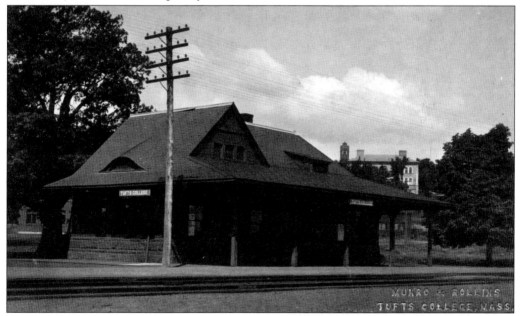

TUFTS COLLEGE STATION, c. 1897. A larger, more comfortable station was constructed in 1897 on Boston Avenue. The advent of trolley service in 1900 dramatically curtailed train service and, by the late 1940s, it had ceased altogether. The trolleys ran down College Avenue and took passengers into Boston for only a nickel. In 1947, the building was purchased for use by the Tufts Drama Department, which used it as a scene shop.

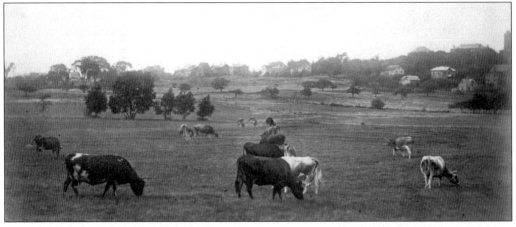

FACULTY COWS, *c.* 1885. The land between College Avenue and Powderhouse Boulevard was used for many years as pasturage for livestock owned by faculty and staff. The rooftops of Barnum Museum, Ballou Hall, and Goddard Chapel tower are barely visible in the upper right.

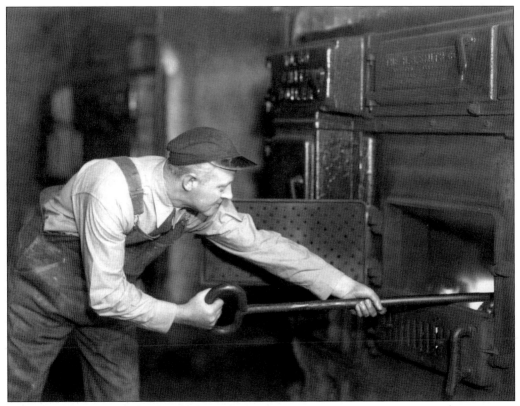

STOKING THE FURNACE, 1939. Coal-fired furnaces provided heat for many college buildings. Janitor William Ashman is shown stoking the fire in the old chemistry lab.

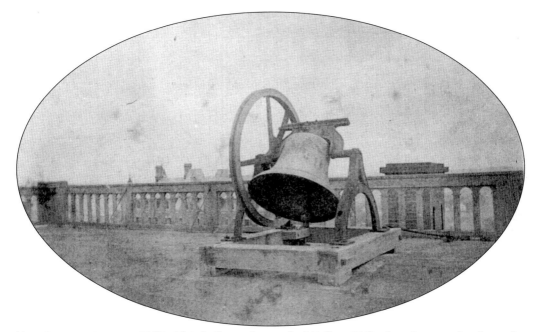

THE COLLEGE BELL, _c._ 1860. This bell on the roof of Ballou Hall, then known simply as the College Edifice, called students to class and daily chapel services, as well as announcing athletic victories to the campus and surrounding communities. Bell ringer was one of the few, if not the only paying jobs available on campus at the time. Pay was $40 per year.

THE BOWEN CHIMES, 1926. Given by Eugene Bucklin Bowen, A1876, who worked as bell ringer as a student, the Bowen chimes filled out the bells in Goddard Chapel tower to a 10-bell carillon. The tower now contains 25 bells, which are rung daily at 5:00 in the afternoon.

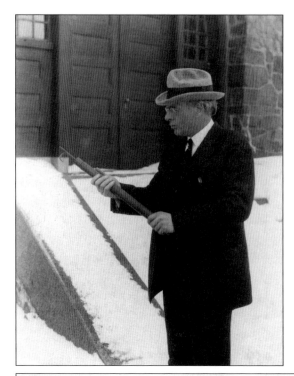

PRESIDENT COUSENS AND JUMBO'S ANKUS, 1923. Pres. John Albert Cousens stands outside a snow-covered Barnum Museum holding the ankus used by Jumbo's keeper. The ankus is part of the P.T. Barnum Collection, which contains a number of artifacts relating to Jumbo's history, including photographs, trading cards, and a puzzle.

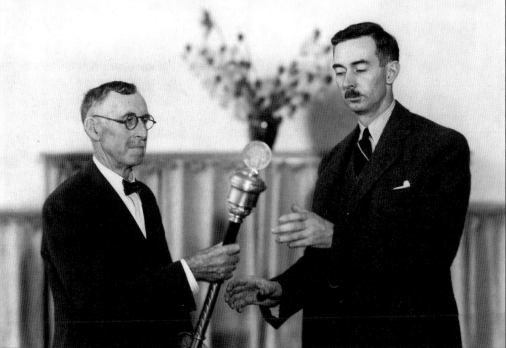

THE MACE, 1938. The mace of Tufts College was created in 1938 and first used in the inauguration of Pres. Leonard Carmichael, pictured on the right. It is used for ceremonial occasions, including commencement. Constructed of rosewood and polished brass, it includes the official seal of the university as the finial, an unusual feature in a university mace.

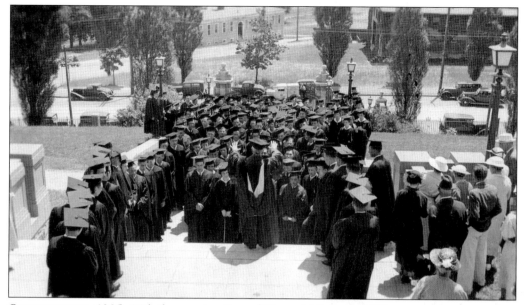

COMMENCEMENT, 1935. With the construction of Memorial Steps in 1929, commencements often incorporated a pause for graduates to gather and remember Tufts men who died in war service.

THE TUFTS GAY COMMUNITY, 1980.
Members of the Tufts Gay Community pose incognito on Memorial Steps. The group, founded in 1971, was established to provide support for students. It is now called the Tufts Transgender Lesbian Gay Bisexual Collective.

THE EVENING PARTY ASSOCIATION, 1913. This student group, which began at least as early as 1890, was responsible for organizing dances open to the whole student body. Held in Goddard Gym, the events featured elaborate decorations, refreshments, and music. By 1940, changing attitudes toward student recreation and the stringency of wartime brought an end to the association.

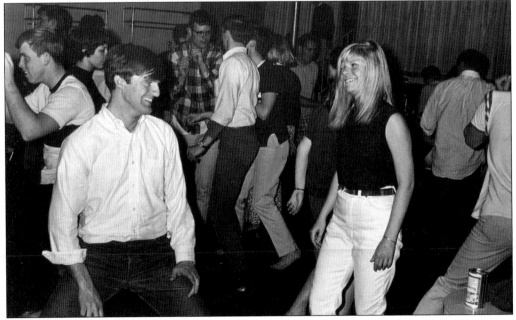

A CAMPUS DANCE PARTY, *c.* 1982. Students dance at MacPhie Pub Night in the early 1980s. Pub Nights, which began in 1977, provided live music and other entertainment for students.

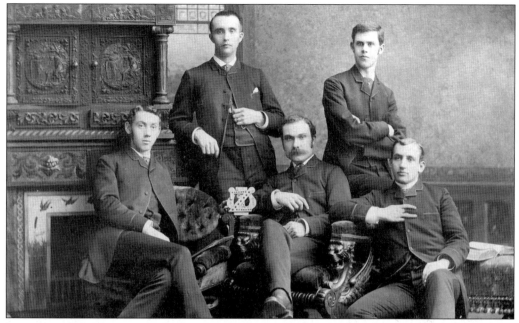

ZETA PSI, 1884. Zeta Psi was the first fraternity established at Tufts. Kappa Chapter was begun in 1855, followed the next year by Theta Delta Chi. For nearly 30 years, these two organizations were the only Greek societies at Tufts. As such, they were central in the establishment of many student activities, including the literary magazine, yearbook, and boating clubs, all of which began as fraternity activities.

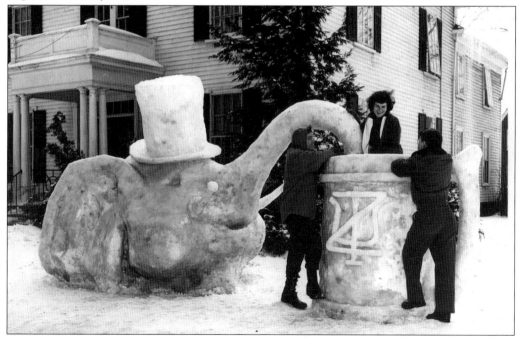

ZETA PSI, 1959. Each winter, fraternities along Professors Row created giant snow sculptures, often featuring Tufts's mascot, Jumbo. It is not known if the real Jumbo drank beer, but his daily feeding regimen did include whiskey.

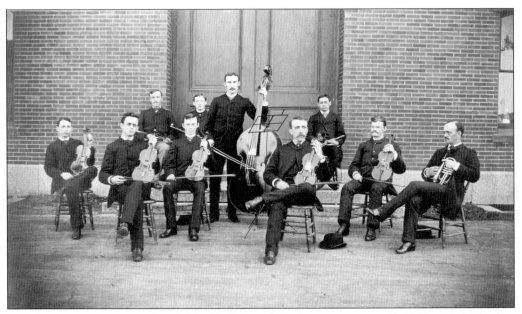

THE ORCHESTRA, 1883. Members of the Tufts Fourth Orchestra pose outside Ballou Hall. The first orchestra was organized in 1871 and had five members. The group had an on-again, off-again existence for many years. This particular group was of sufficient caliber to attract professional musicians to fill out the sections. First violin was Frederick Stark Pearson, E1883, noted engineer and entrepreneur, seen here second from the left.

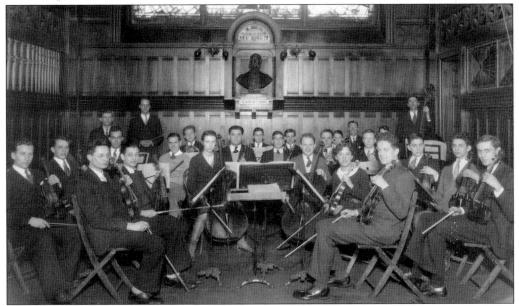

THE ORCHESTRA, 1934. By 1934, the orchestra was on a solid footing, regularly numbering 30 to 40 members. In addition to concerts in Goddard Chapel, pictured above, the orchestra traveled to local communities and broadcast performances over the Tufts radio station. Lawrence Chidester was the conductor. Chidester originally came to Tufts as a teaching fellow in economics, but his acumen in orchestral training and organization soon occasioned a transfer to the music department.

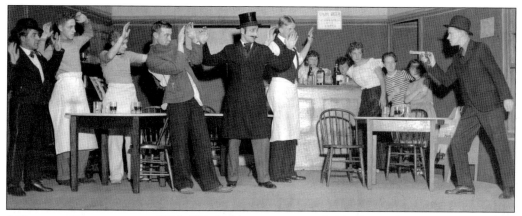

A DRAMATIC PRODUCTION, C. 1920. This holdup scene is probably from a play by Pen, Paint, and Pretzels, an undergraduate theater group. Formed in 1910 to perform plays written by Tufts students and faculty, the group gradually expanded its repertoire to include plays by other authors. Its unusual name refers to authors' pens, artists' paints, and the audience's pretzels.

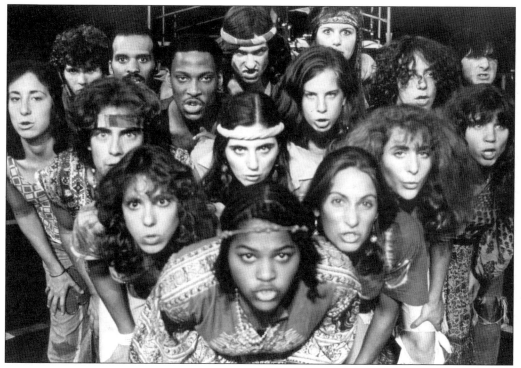

HAIR, **1985.** In 1985, Torn Ticket II, a student-run musical theater group, staged a revival of *Hair* to rave reviews. Torn Ticket II was formed in 1982 by the merger of two musical theater groups, Torn Ticket, which did full-length productions, and Top Hat and Tails, which concentrated on short revues.

THE DENTAL SCHOOL WIVES, 1958. Pres. Nils Wessell poses with these recipients of the "P.H.T. degree." Standing for "putting him through," the certificates were given in recognition of the important and supportive roles wives were perceived to play in helping their husbands finish dental school.

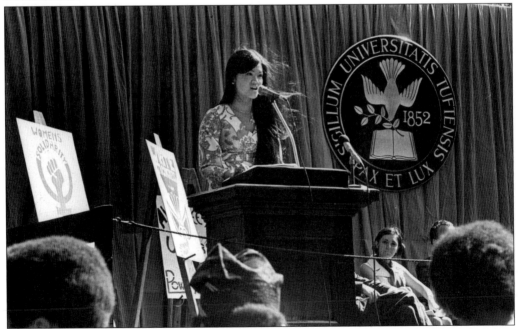

THE STUDENTS' COMMENCEMENT, 1970. In 1970, almost the entire graduating class boycotted the university's commencement ceremony to protest the continuing presence of military recruiters on campus and in solidarity with students at Kent State. The graduates held their own ceremony the next day with their own speakers and handed out flowers instead of programs against a backdrop of posters proclaiming women's solidarity.

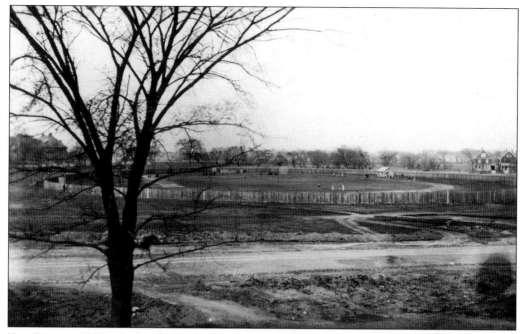

THE OVAL, C. 1899. The Oval was the first formal athletic field at Tufts, so named for the shape of the wooden fence surrounding it. The fence and seating for spectators was constructed in 1894, with alumni donations totaling $2,000. Unfortunately, the wooden fence made excellent bonfire fodder and was eventually replaced with wire. The cinder track visible here was installed in 1899.

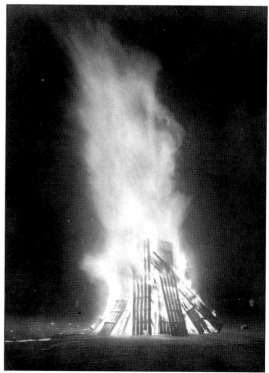

A BONFIRE, 1919. Bonfires such as this one lit to celebrate the Tufts baseball team's 7–3 victory over Yale were once common. The danger of bonfires lay not only in the threat to trees and buildings, but also the damage students did in searching for fuel. Fences and billboards were favorites, and Tufts students were in trouble with college officials and local police on more than one occasion for their zeal in commandeering combustibles.

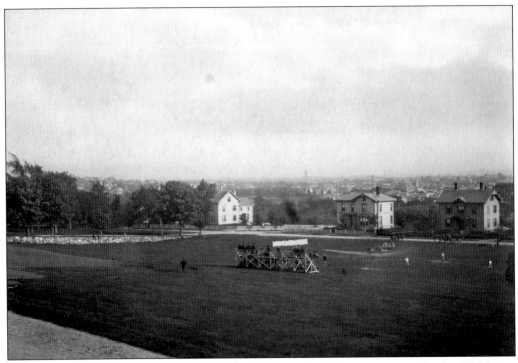

BASEBALL ON THE OLD CAMPUS, *C.* **1900.** The field known as Old Campus, now Fletcher Field, was frequently used for baseball games in early years. The homes of Profs. Shipman, Fay, and Bray can be seen in the background, evidence of how Professors Row got its name.

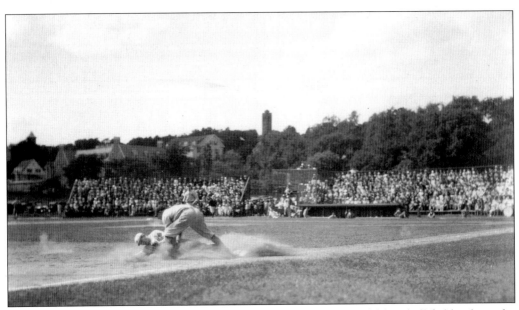

BASEBALL, *C.* **1930.** This action shot of a baseball game shows the old baseball field, where the Oval is now. Originally, baseball games were played on Fletcher Field, but the extension of Professors Row made the field unacceptably small. This field, however, had an added hazard called the Artificial—a pond that made fielding long fly balls particularly dangerous.

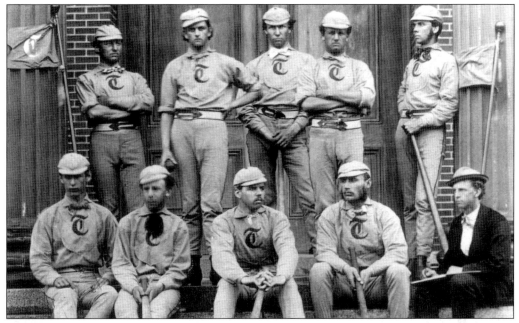

BASEBALL, 1870. The first baseball game played at Tufts was a match between the freshman and sophomore classes in 1863. Soon afterward, baseball became an organized sport and a regular part of college life at Tufts. By 1870, the team had uniforms and was playing other college teams from around New England.

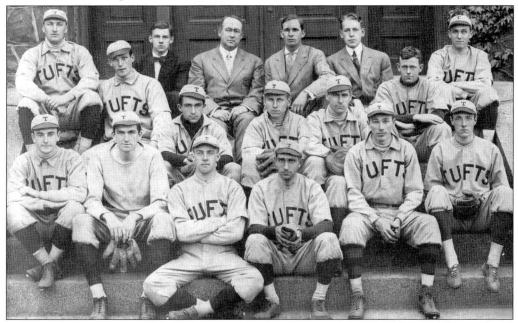

BASEBALL, 1908. By 1908, the uniforms and equipment were quite similar to those of today. In 1950, the team played in the College World Series, losing to Nebraska. Nearly a dozen Tufts baseball players have gone on to the major leagues. At least one major leaguer made the trip the other way around—Andrew Spognardi, M1936, graduated from Tufts's medical school after playing for the Boston Red Sox in 1932.

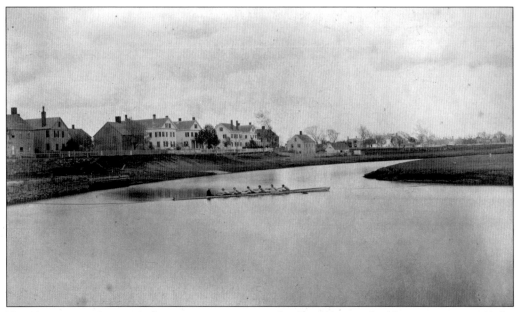

THE TUFTS BOAT CLUB, 1874. Boating was among the first organized athletic activities at Tufts, beginning in 1864 with clubs established by two fraternities. Later, an all-Tufts boating club was established which, by 1874, had 25 members. The relatively short distance from the campus to Mystic River and Mystic Lakes in Medford made water sports popular, though the Tufts Yacht Club was not established until 1936.

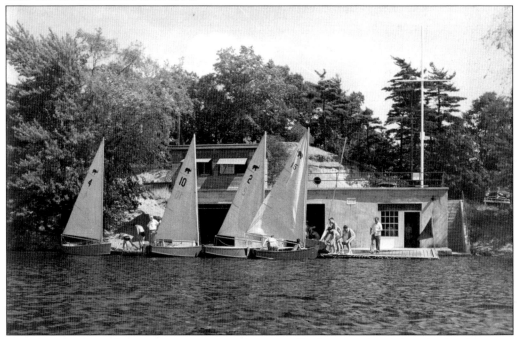

THE YACHT CLUB, 1962. Located on Mystic Lake in Medford, the Yacht Club is the headquarters for Tufts's sailing clubs and crew teams. It was constructed in 1948, though boating got its start at Tufts many years earlier. Tufts's sailing teams have won numerous national championships over the years.

THE CONSTRUCTION OF THE GOLF COURSE, 1924. The golf course was constructed on an old cow pasture behind the old Jackson Gymnasium, later the Arena Theater. Students were asked to volunteer five hours per week for construction, and physical education classes substituted construction work for their normal curriculum. At the time of its completion, the golf course was claimed to be the only one on a college campus in the United States.

THE GOLF COURSE, c. 1950. The golf course, which began with six holes, was cut to five in 1948 to make room for Jackson Gym, pictured in the background of this photograph. In the early years of its use, strict rules governed attire and behavior on the course, though these were later made less stringent. In 1958, the last holes were destroyed to make room for Bush Hall and Tilton Hall.

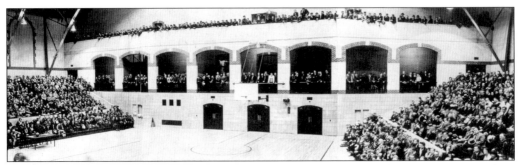

Cousens Gymnasium, 1931. Goddard Gymnasium was replaced in 1931 with a large, modern facility named for Pres. John Albert Cousens. Shown here on its opening night, the new gym offered dramatically larger space with a baseball cage, basketball courts, and an indoor track.

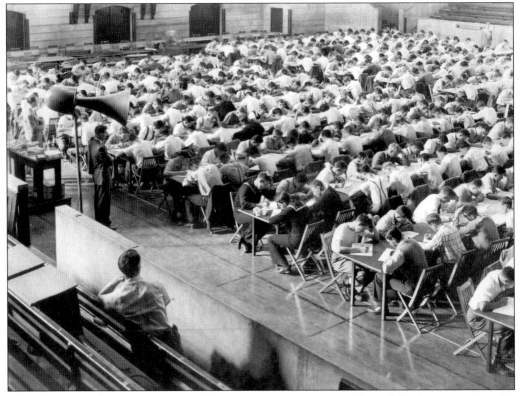

Exam Time, c. 1948. In addition to athletic events, Cousens Gym hosted final examinations for the largest classes at Tufts, with proctors monitoring students' performance.

THE DOG CART, c. 1905. This small shack next to Curtis Hall served the college as a dining establishment one year, when the college dining hall was only in sporadic operation. With few dining options in the immediate vicinity of campus, an enterprising local man opened the "dog cart," as it came to be known, and did a booming business until the regular dining hall was reopened.

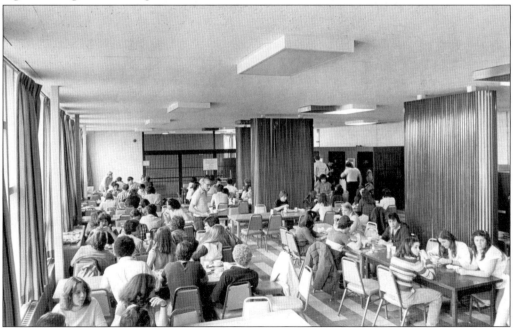

DEWICK HALL, c. 1982. Dewick Hall and adjoining MacPhie Hall, originally built for Jackson students, provided a popular spot for "downhill" dining. In 1995, the two dining halls were renovated to provide a new, state-of-the-art dining facility for students.

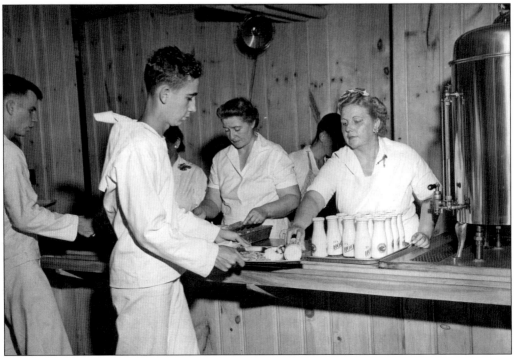

NAVY ROTC MESS, *c.* 1943. Trainees move through the line in the mess hall in Curtis. Note the Hood milk bottles handed out to each sailor. During World War II, Curtis Hall became the mess hall for all of the U.S. Navy training programs on the Medford Campus.

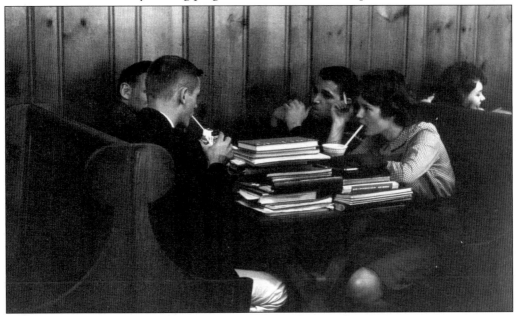

THE KURSAAL, *c.* 1954. The Kursaal was a popular spot for relaxation between classes. Originally located in Cousens Gym and later in Curtis Hall, it was a lunchroom and soda fountain. It was named by Pres. Leonard Carmichael upon its opening in 1940. Kursaal was a term used to designate a social hall at a resort, and Carmichael felt it to be an apt name.

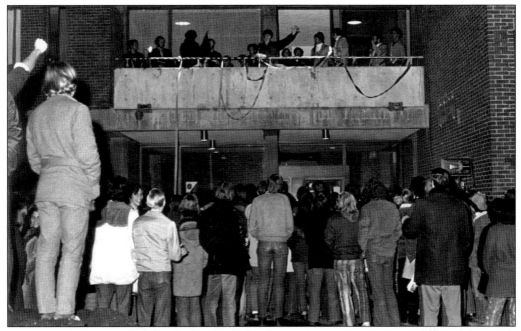

THE DEDICATION OF "FREEFER HALL," 1970. "Freefer Hall" was the name given to the new dormitory in this mock dedication ceremony, before it was dedicated to Leo Lewis in 1972. Lewis Hall was the first coeducational dormitory at Tufts. Its construction was plagued with unrest as students, led by the newly formed Afro-American Society, protested the underrepresentation of minority workers on the contractor crews.

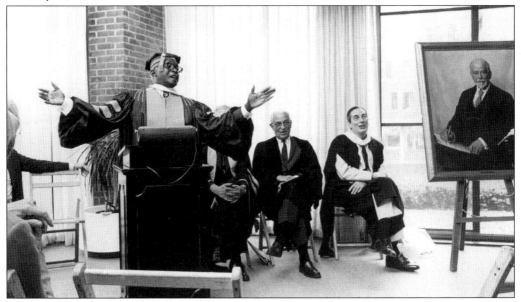

THE DEDICATION OF LEWIS HALL, 1972. Jester Hairston, A1929, was a well-known jazz musician, bandleader, and actor. When the decision was made to name the new dormitory for Leo Lewis, composer of Tufts's Alma Mater and other songs, it was fitting to honor Hairston. Hairston composed more than 300 spirituals, made countless recordings, and appeared on stage, television, and screen in an era when being an African American actor was notoriously difficult.

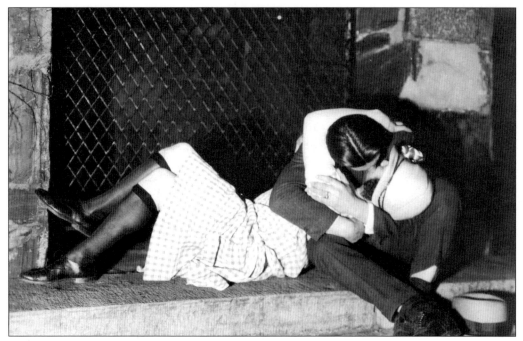

The Chapel Steps, c. 1927. This shot was captioned by photographer and professor Melville Munro, "Were you one of those naughty boys or girls who got themselves written up in the Year Book of ?-?-? under the title of Scandal?" Although this picture was most likely staged, the chapel steps, offering relative privacy and fine view of the Boston skyline, may well have been a favorite rendezvous spot.

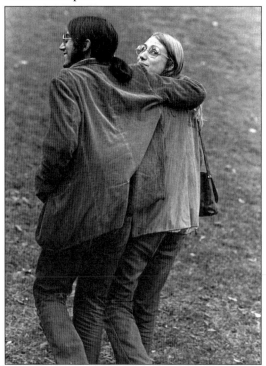

A Campus Couple, c. 1970. By the 1970s, attitudes toward relationships among students had changed dramatically. Students could stroll across campus arm in arm without fear of being labeled scandalous.

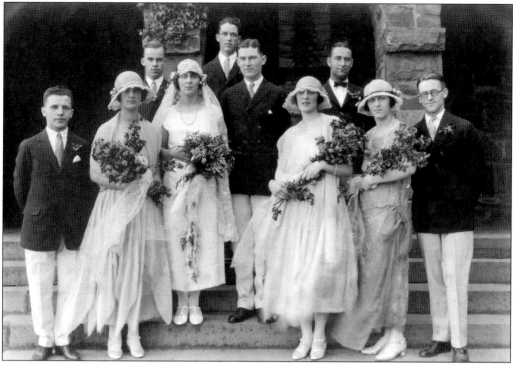

A GODDARD CHAPEL WEDDING, c. 1924. Over the years, many Tufts couples have been married in Goddard Chapel, though it is unclear when the first wedding took place there. The chapel has been a favorite choice for interfaith couples, and such marriages have become increasingly frequent.

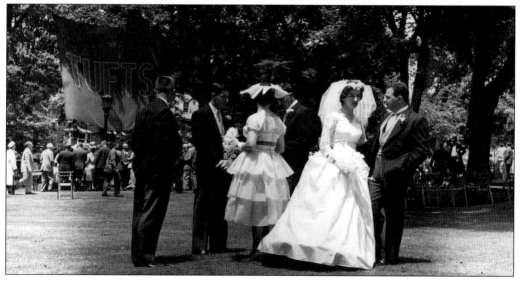

A CAMPUS WEDDING, c. 1950. This wedding coincided with commencement. Weddings sometimes had unusual elements. One couple had a small plane fly a banner over the chapel to announce the occasion, and at another wedding of a military academy cadet, a gun salute was fired on the patio outside. Unfortunately, neither chapel staff nor campus police had been warned of what was about to take place and the sound of gunfire caused alarm.

THE BUBBLE, *c.* **1905.** This water fountain, called the Bubble, was located next to Packard Hall on the site of the original College Pump. The pump was installed in 1888, where a well had been in use for many years. It was occasionally used to dunk students who broke freshman rules. After the water was found to be polluted in 1900, it was no longer used for drinking and it was removed sometime after 1944.

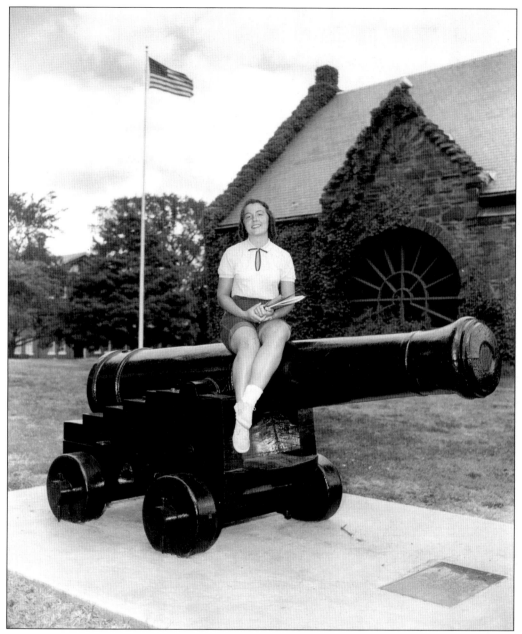

THE CANNON, *c.* 1965. The cannon, a fixture on the Medford campus, is a replica of an original cannon from the USS *Constitution,* "Old Ironsides." It was a gift from the city of Medford in 1956. Since 1977, it has been used by students, groups, and individuals, who paint messages on the cannon under cover of night.

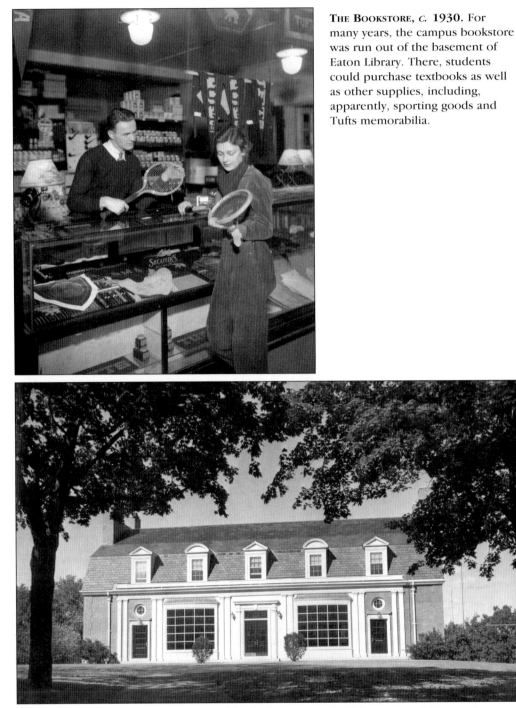

THE BOOKSTORE, C. 1930. For many years, the campus bookstore was run out of the basement of Eaton Library. There, students could purchase textbooks as well as other supplies, including, apparently, sporting goods and Tufts memorabilia.

THE BOOKSTORE, C. 1948. By the late 1940s, the bookstore in the basement of Eaton Library was no longer adequate for the growing demands placed upon it. A new building, which Pres. Leonard Carmichael dubbed the Taberna, was constructed on the quad to house the bookstore. When the bookstore moved to the new Campus Center in 1987, the building was given over to the Office of Undergraduate Admissions and renamed Bendetson Hall.

Four

CITIZENSHIP

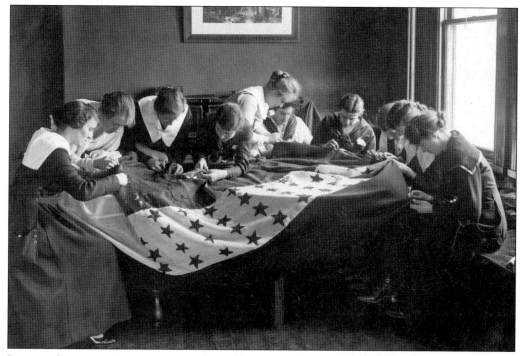

JACKSON STUDENTS MAKING SERVICE FLAG, MARCH 1918. During World War I, Tufts displayed service flags in Goddard Chapel, with one star for each Tufts man serving in the armed forces.

THE SUFFRAGE PARADE, 1915. In 1915, Jackson students organized a local chapter of the College Equal Suffrage League. Organized by Ruth Sibley Haskell, a graduate student, the group brought speakers to campus and into the community.

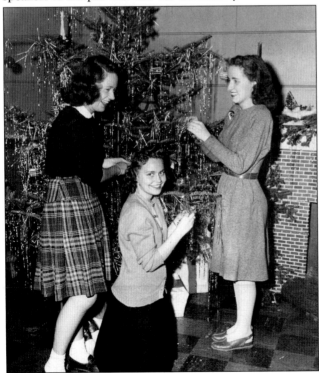

CHI OMEGA, 1946. These Chi Omega girls are decorating a tree for a holiday party at the South End House in Boston. Greek letter societies at Tufts have long built community service into their programs. Chi Omega is one of the oldest sororities at Tufts, founded in 1910, the same year as Jackson College.

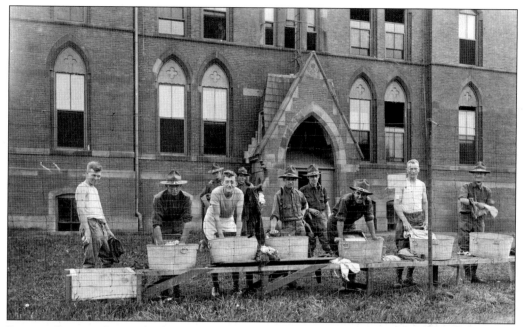

LAUNDRY DAY, c. 1918. As Tufts did its part for the nation in World War I, West Hall, pictured in the background, was converted to serve as barracks for trainees in the Student Army Training Corps (SATC). This corps trained enlisted men for special military assignments. Trainees mustered on the quad, trained on the athletic fields, and scrubbed their own laundry.

CARMICHAEL HALL, 1955. Completed in 1954, Carmichael Hall was constructed to serve as a dormitory for men in the Naval Reserve Officers Training Corps (NROTC). The NROTC program had a significant presence on the campus from World War II through the 1970s, during which time students in the program could earn a B.S. in naval science.

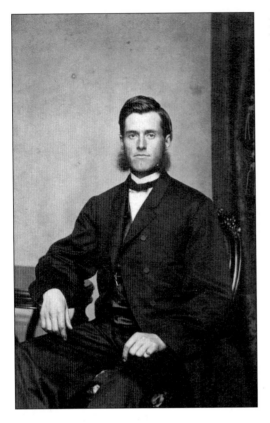

HORATIO BISBEE, 1863. Bisbee was the first Tufts man to enlist in the Union Army in the Civil War. He left Tufts in 1861 to join the 5th Massachusetts Regiment and saw action at Bull Run. After a tour of duty recruiting for the 1st Maine Regiment, Bisbee returned to Tufts, graduating in 1863. Later, he went on to become a congressman and attorney general for Florida.

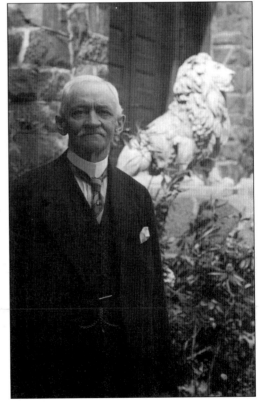

EUGENE BUCKLIN BOWEN, *c.* **1923.** Bowen, E1876, a devoted alumnus, gave many gifts to the college during his lifetime, including the lions outside Barnum Hall. As an undergraduate he held the only paying student job on campus—that of bell ringer. He also was a member of the first Tufts football team. At the time of his death in 1952, Tufts's centennial year, Bowen was the school's oldest living alumnus.

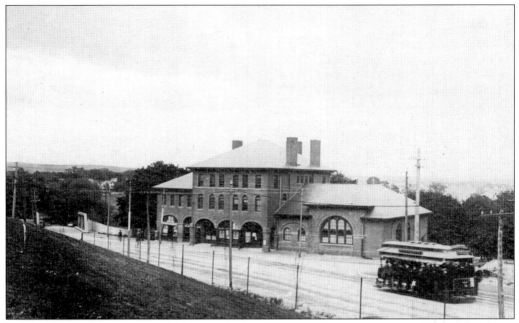

CURTIS HALL, c. 1895. This photograph shows Curtis Hall, a few years after its construction in 1892, and the trolley line that used to run into Cambridge and Boston. Curtis Hall was built as a multipurpose building with facilities for a dining hall, post office, residential spaces for fraternities and sororities, and offices for student groups.

CURTIS HALL, 1970. In the turbulent years of the Vietnam era, Tufts students were actively involved in protests against the war. A general strike was called by students in April and tacitly allowed by the administration. Through the end of the semester, students and faculty organized antiwar activities out of the strike center in Curtis Hall.

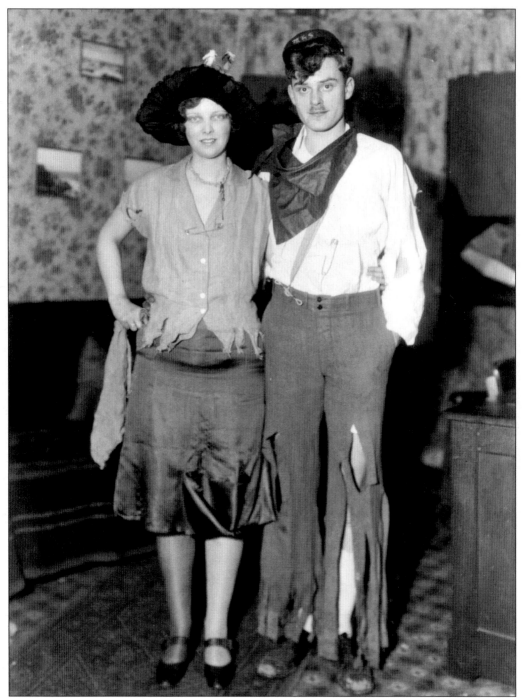

A POVERTY PARTY, 1930. This couple are dressed in their best rags for a Poverty Party at the Delta Upsilon fraternity. Although some students could use humor to cope with the Depression, the college pulled through with only strict fiscal discipline and paring of budgets across the board. A limitation of all new faculty or staff appointments to one year remained in place until 1936, though no permanent positions were lost due to the Depression.

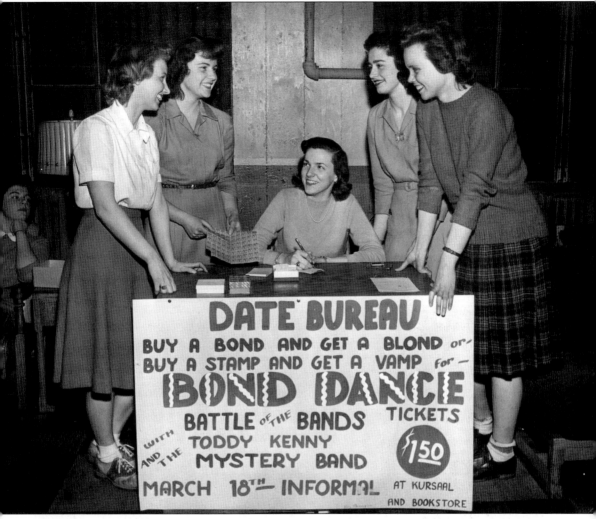

THE DATE BUREAU, 1944. Instead of the War Bureau, these students from Jackson College and the Bouvé-Boston School of Physical Education oversee the Date Bureau, raising money for war bonds by selling dance tickets. Fund-raisers were just one example of women students' involvement on the home front.

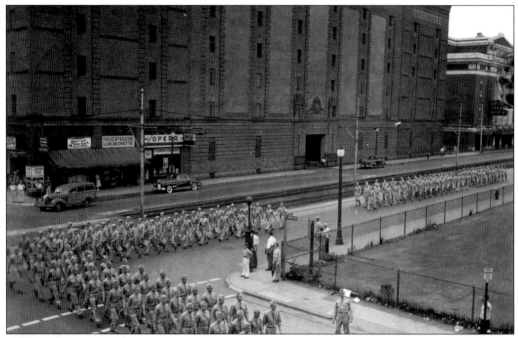

MEDICAL STUDENTS DRILL, c. 1943. During World War II, many students in the medical school joined the Army Specialized Training Corps. Here, the students drill on the streets, adjacent to the medical school's Huntington Avenue location in Boston.

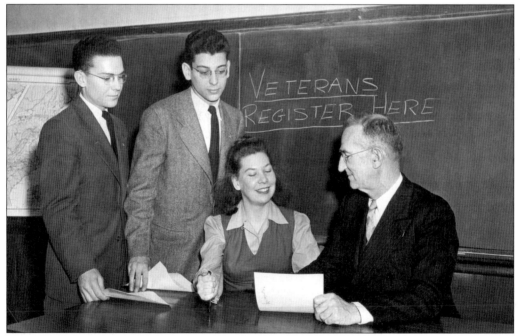

THE SCHOOL FOR WAR VETERANS, 1945. During and after World War II, Tufts set up a special office to facilitate the return of veterans to their studies. Called the School for War Veterans, it assisted veterans with their reentry into academic life and helped them understand their rights under the G.I. Bill. A veterans service center continued to exist at Tufts into the 1950s.

THE WAR GARDEN, 1918. As the campus shifted to a war footing during World War I, Jackson students cultivated vegetables on campus as part of the general conservation effort. Anthony House and Capen House are visible in the background.

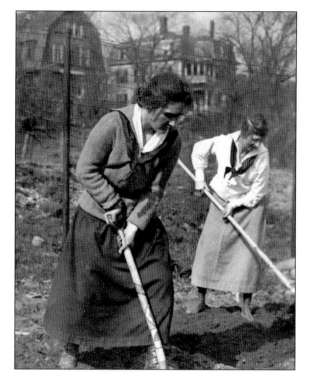

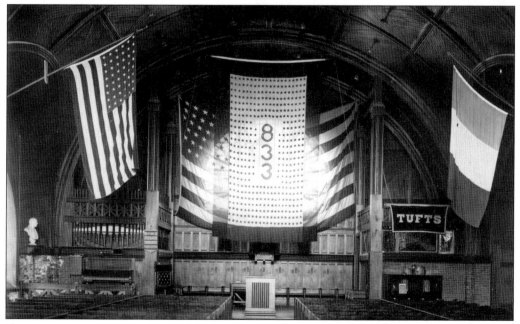

THE SERVICE FLAG, 1919. The service flag displayed here in Goddard Chapel contains one star for every Tufts man serving in the armed forces in World War I. It served as a constant reminder, along with the American and French flags, of Tufts's role in the conflict. Chapel services were still compulsory at this time, three days per week for all undergraduates.

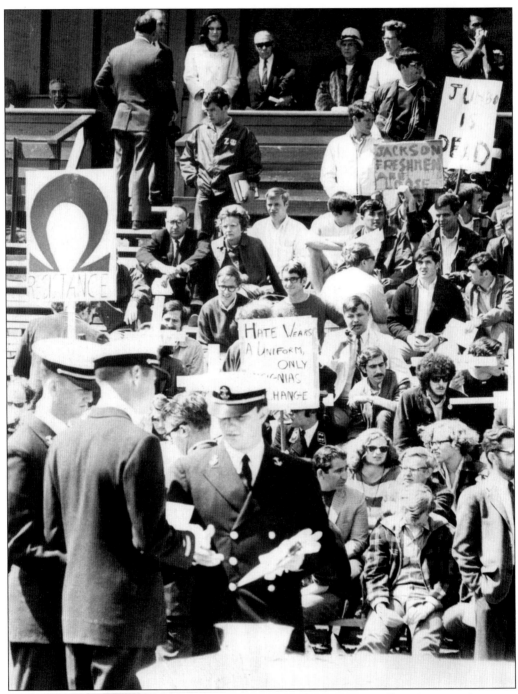

ROTC PROTEST, 1968. Students protest the presence of the Reserve Officer Training Corps on campus. In the 1940s and 1950s, participation in ROTC was high enough that it had its own dormitory and instructional facilities on campus. By the early 1970s, however, antiwar feeling had grown to the extent that the program was moved to MIT and Tufts participants were often harassed when in uniform. The signs in the background show that not all students took this as seriously as those involved on opposite sides of the debate.

ROTC March, 1971. Members of Tufts's ROTC units march on the athletic fields by Ellis Oval on the Medford Campus. The on-campus ROTC programs were eliminated at Tufts in 1973 and participants traveled to MIT to be part of a regional program.

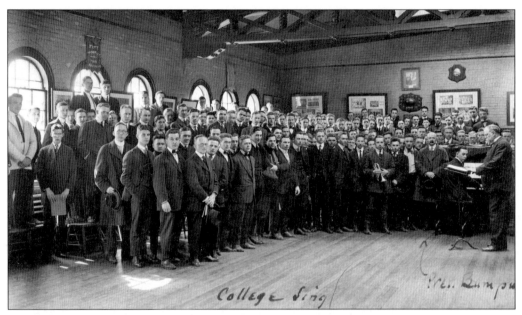

A COLLEGE SING, 1915. Held on the mezzanine level of Goddard Gym, this College Sing was led by Leo Lewis, Tufts graduate, professor of music, and composer of numerous Tufts songs. Sings were held throughout the year, most often at Christmas and in the spring. Rival classes or dormitories would perform a song to be judged in what was often a competitive endeavor. President Hermon Bumpus is at the end of the first row.

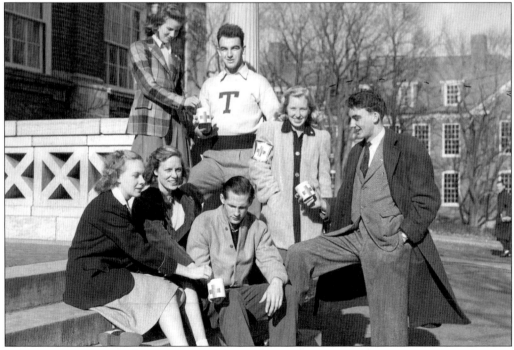

A RED CROSS DRIVE, 1941. Members of the Tufts Student Council are pictured here during a fund-raising drive for the American Red Cross. Drives were one of many ways students mobilized to assist the war effort on the home front.

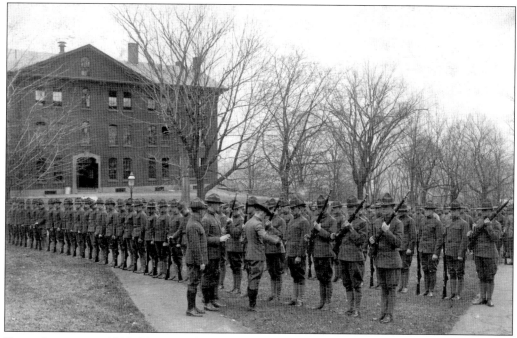

TROOP INSPECTION, 1918. Troops mustered out from their barracks in East Hall for this Saturday morning inspection. During World War I, such sights were commonplace, as hundreds of students joined the Student Army Training Corps prior to shipping out to the battlefield.

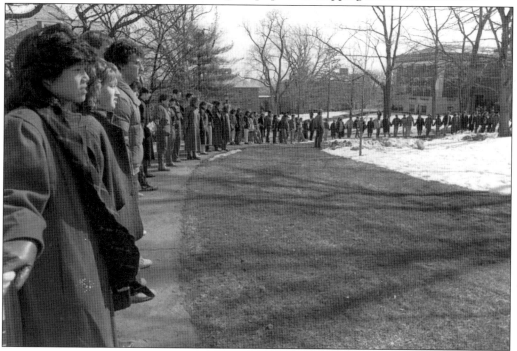

A RALLY AGAINST RACISM, 1987. Students joined hands in February 1987 in a protest against racism. Approximately 400 students, faculty, and administrators gathered to listen to speakers outside Goddard Chapel, followed by a brief occupation of Ballou Hall.

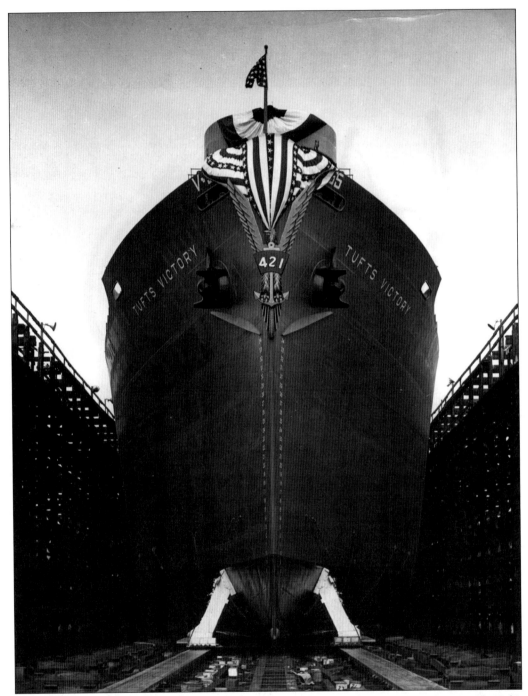

THE SS *TUFTS VICTORY*, 1945. The SS *Tufts Victory* was a Victory Ship launched in March 1945, one of a series named for American colleges and universities. It carried equipment and troops in the last months of World War II. The Tufts name was also carried on a Liberty Ship, the SS *Charles Tufts,* named for the donor of the land at the core of Tufts's Medford campus.

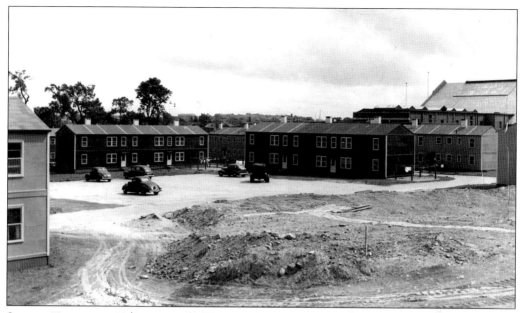

STEARNS VILLAGE, C. 1947. Stearns Village provided much-needed housing for married veterans attending Tufts on the G.I. Bill after World War II. It was constructed on land donated by the widow of George L. Stearns, a local businessman, adjacent to Cousens Gymnasium, whose sloping roof can be seen on the right. The structures had originally housed employees at an aircraft plant in Connecticut, but were brought to Medford in 1947.

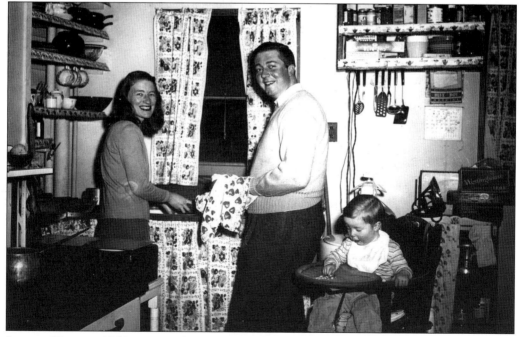

STEARNS VILLAGE, 1948. A typical kitchen in a Stearns Village apartment shows the cramped quarters for growing families. The village's enterprising mothers established a baby-sitting cooperative to facilitate outings for young parents. Never intended to serve as permanent structures, the village was torn down in 1955, after the collapse of one of the units.

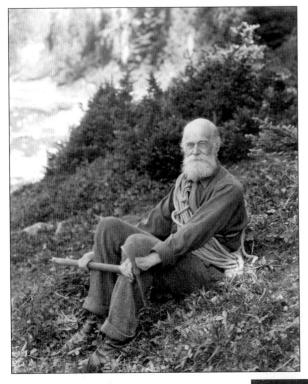

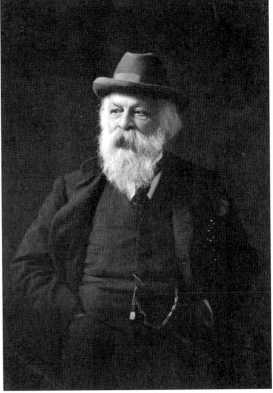

PROF. CHARLES E. FAY, 1924.
Professor Fay (1846–1931), A1868, H1928, was professor of modern languages for more than 60 years. He was also an internationally known mountaineer, who ascended many peaks around the world. In recognition of his exploits in the Canadian Rockies, the Canadian government named Mount Fay in his honor.

BENJAMIN BROWN, c. 1880. Professor Brown was Walker Professor of mathematics from 1865 until his death in 1903, as well as teaching physics, astronomy, Latin, and Greek at various times. Brown was an active member of the local community and was a member of the Somerville School Board, which named an elementary school in his honor. His daughter, Henrietta, was the first woman to graduate from Tufts.

FRED STARK PEARSON, C. 1900. Fred Stark Pearson (1861–1915) E1883, G1884, H1900, H1905, was an electrical engineer, who revolutionized city rail systems and pioneered the use of hydroelectric power. An entrepreneur as well as scientist, Pearson became a multimillionaire by his early thirties. He died in the sinking of the *Lusitania* while on his way to London to consult on a hydroelectric project.

PEARSON CHEMICAL LABORATORY, C. 1948. Pearson was constructed in 1923 for the Department of Chemistry, which had drastically outgrown its facilities in the Research Building on Boston Avenue. The new building was named in 1926 for Fred Stark Pearson. The Michael Laboratory was added to the building in 1964.

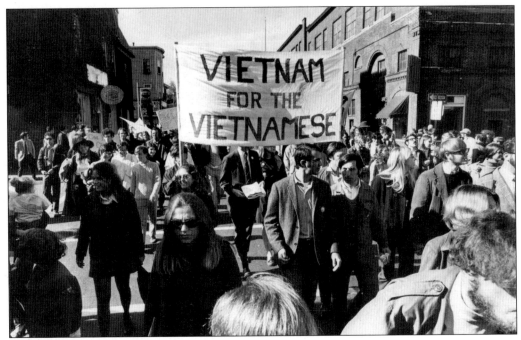

A VIETNAM PROTEST, 1969. As the conflict in Vietnam continued, student activism against the war increased. By the spring of 1967, a chapter of Students for a Democratic Society was established at Tufts and sponsored numerous teach-ins and protests. Antiwar feeling peaked at Tufts with the firebombing of the Fletcher School of Law and Diplomacy, which traditionally had close ties with the military community.

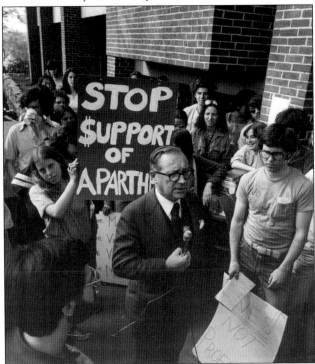

APARTHEID PROTESTS, 1978. A routine financial report in 1977 revealed Tufts investments in companies doing business in South Africa, then governed under the system of apartheid. Angry that Tufts was supporting the racist government, students called for divestment. President Jean Mayer, center, resisted, stating that Tufts's divestment alone would not be an effective protest. Student outcry continued until 1989, when the trustees voted unanimously for Tufts to divest.

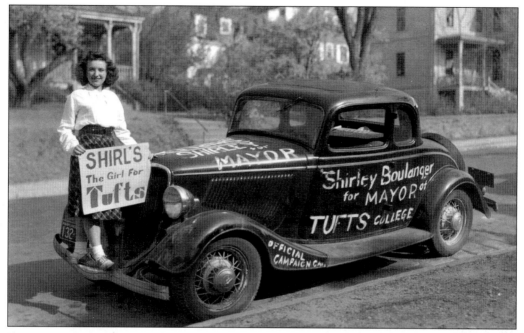

THE MAYORALTY, 1940. Each spring from the 1930s to the 1960s, Tufts undergraduates rallied to elect an unofficial mayor of Tufts. The mock political elections were a celebration of school spirit and an opportunity to let off steam before finals. Candidates generally ran under whimsical names, such as "Captain Question Mark" and "Stuporman." Shirley Boulanger, pictured here, was the first woman to run for mayor.

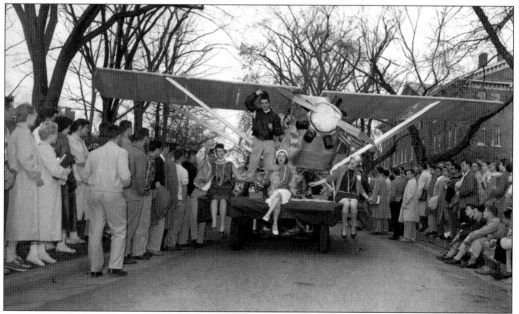

THE MAYORALTY, 1956. Mayoralty campaigns often involved elaborate floats and costumes. On at least one occasion, the escapades went beyond the Tufts campus, when "Buccaneer" Meehan, in full pirate garb, captured the Swan Boats in Boston's Public Garden. Mayoralties were held intermittently into the late 1960s.

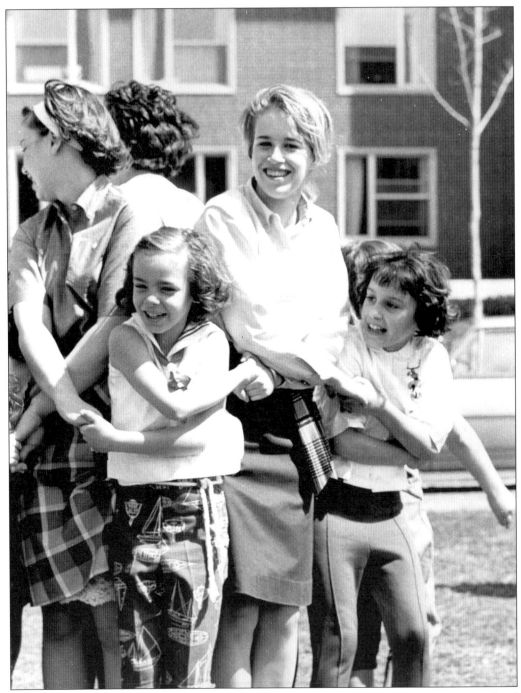

KID'S DAY, 1964. Each year, the Leonard Carmichael Society sponsors Kid's Day, inviting local children to campus for a day of fun activities. The society, founded in 1958, is an umbrella organization for a wide variety of community service activities. It is named for Pres. Leonard Carmichael, who built a career around service to organizations such as the Smithsonian Institution and the National Geographic Society.